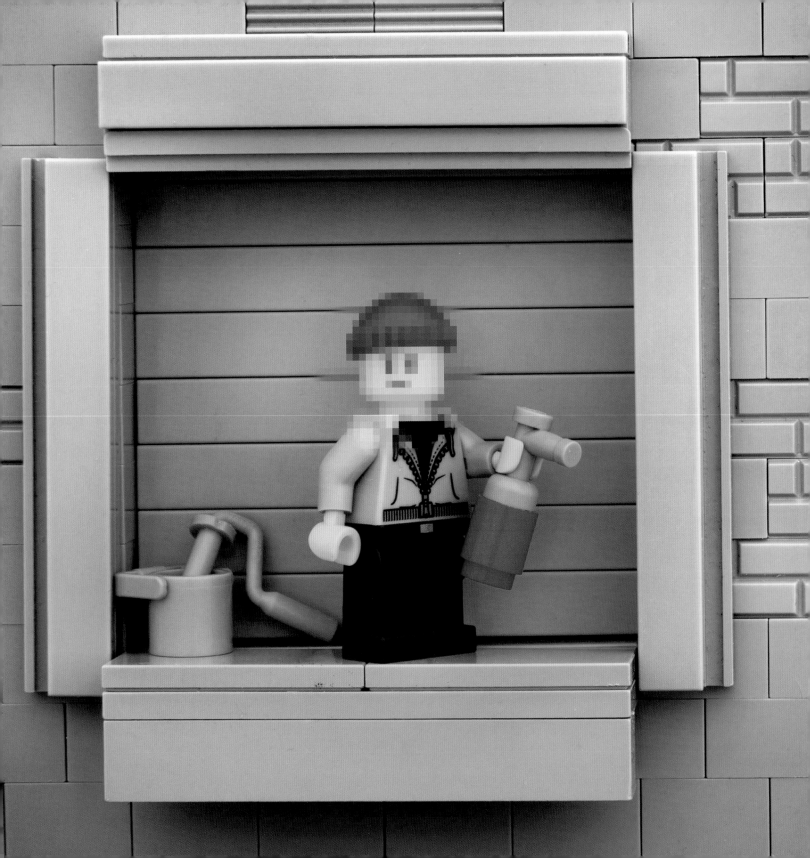

UNAUTHORIZED UNDERGROUND BRICK STREET ART

BRICKSY

BY JEFF FRIESEN

Skyhorse Publishing
New York

Skyhorse Publishing books may be purchased in bulk at special discounts for sales promotion, corporate gifts, fund-raising, or educational purposes. Special editions can also be created to specifications. For details, contact the Special Sales Department, Skyhorse Publishing, 307 West 36th Street, 11th Floor, New York, NY 10018 or info@ skyhorsepublishing.com.

Skyhorse® and Skyhorse Publishing® are registered trademarks of Skyhorse Publishing, Inc.®, a Delaware corporation.

Visit our website at www.skyhorsepublishing.com.

10 9 8 7 6 5 4 3 2 1

Library of Congress Cataloging-in-Publication Data

Friesen, Jeff (Photographer)
 [Photographs. Selections]
 Bricksy : unauthorized underground brick street art / by Jeff Friesen.
 pages cm
 ISBN 978-1-63450-479-9 (hardback)
 1. Photography, Humorous. 2. Staged photography—Canada. 3. Banksy—Parodies, imitations, etc. 4. LEGO toys—Pictorial works. I. Title.
 TR679.5.F75 2015
 770—dc23
 2015008359

Cover design by Jeff Friesen and Eric Kang
Cover photos credit © Jeff Friesen

ISBN: 978-1-63450-479-9
Ebook ISBN: 978-1-63450-862-9

Printed in China

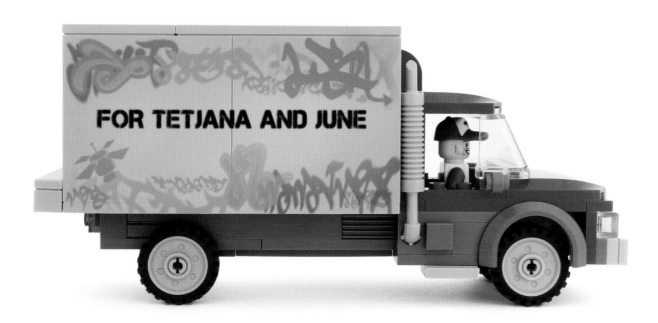

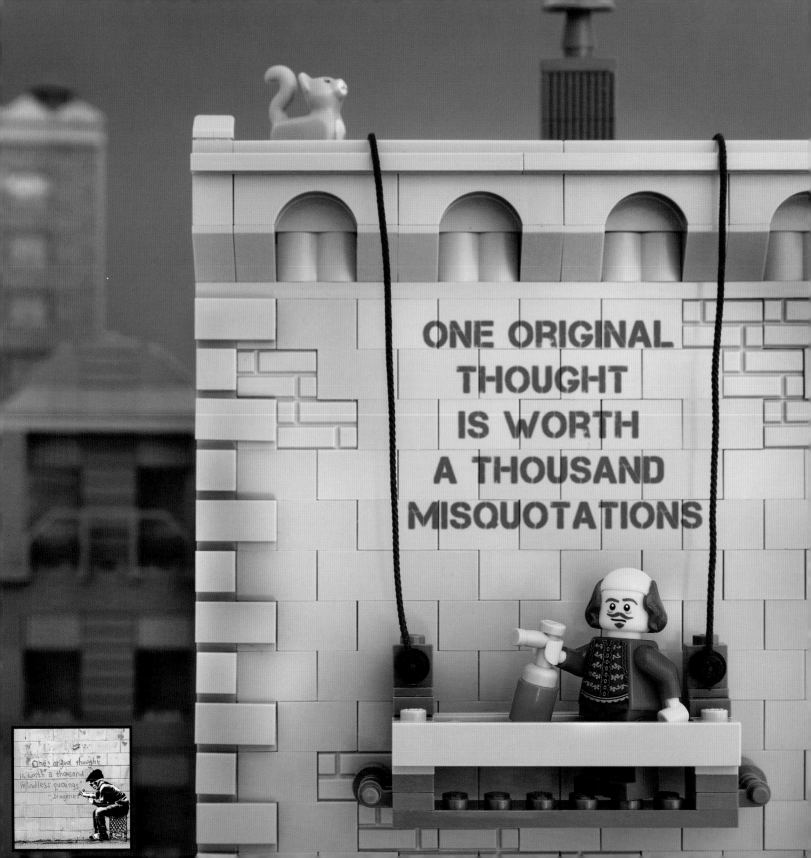

ONE ORIGINAL
THOUGHT
IS WORTH
A THOUSAND
MISQUOTATIONS

Table of Contents

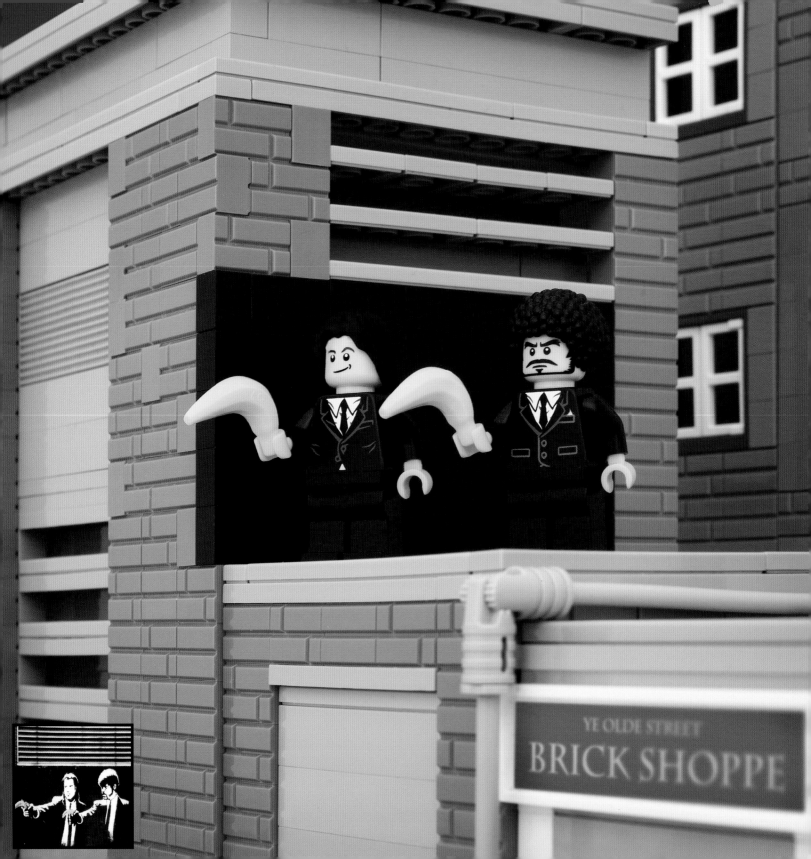

Introduction

What would civilization be like if the two parts of our classic pairings had never combined? Imagine a world without bread and butter, Bert and Ernie, or ill-tempered cats and people willing to exploit them for personal gain. Consider a culture deprived of Tarzan and Jane, Itchy and Scratchy, or singing astronaut Chris Hadfield and his sentient mustache. Harmonious pairings are a central focus of the human condition. Every Clyde needs a Bonnie, and every Robin needs a brooding, costumed man who likes to fight with clowns.

This book is not about a perfect pairing. The union depicted on the following pages makes less sense than the pronunciation of Worcestershire sauce. It's a clash of two cultural titans that are as different as *Knight Rider* and *Happy Days*. Between you and me, I'm surprised this book was even published, so hold on tight to your copy before it disappears like so many of life's little miracles.

Let's meet the two parts of this madcap mash-up. First up is the street artist, Banksy.

Picture the street artist Banksy in your mind. It's hard to do because he usually appears with a low-pulled hood and strong backlighting. His voice is also distorted with a peculiar accent, possibly originating from Middle Earth. It has been rumored the he is actually a she, or perhaps a

band of merry art vandals. For all we know he might be a highly evolved, strategically shaved monkey with a fondness for khaki pants.

The Internet, so knowledgeable and nonhysterical about so many things, has yet to offer a definitive explanation of who Banksy is. The truth is that Banksy cultivates mystery like a farmer of questionable similes.

While we don't know who Banksy is, we do know what he does. Banksy's rise from Bristol-based graffiti artist to the world's most famous anonymous art star is the art world story of the entire millennium—and we're more than a dozen years into it now.

With Banksy at the tip of the cultural spray can, an entire art revolution has been painted into existence. Street art, once generally regarded by the art establishment with the same fondness as a mediocre wine pairing, is now welcome inside the most chichi of art galleries. Street art has even become de rigueur for artist publicity. It's getting to the point where we may see Gerhard Richter making his squeegee paintings on parked car windows.

No matter how glamorous it has become, street art, by its essential nature, takes place in the street. It must be criminal, however benignly, or it moves over to the category of committee-approved public art. For that reason street art often takes place in grimy, squalid corners riddled with vermin such as art dealers prying stencil-painted bricks out of the wall.

Let's leave the grunge and misdemeanors of the street art world and meet the sunnier second half of this mix: LEGO.

LEGO is a building toy based on a system of interlocking bricks, but you already knew that, provided you spent at least part of your childhood on earth. LEGO is bright, glossy, and clean, with the modernist sensibilities of a Mondrian painting. It remains perfectly legal to play with LEGO, even at an awkwardly older age. Take away any adjective you can use to describe street art, and what you're left with looks a lot like LEGO.

What you're about to see takes everything missing from Banksy's street art and combines it with everything missing from LEGO. The two disparate elements are patched together in odd places and bolted down where no glue would stick. (Not that LEGO should ever be glued, patched, or bolted; these are metaphors.) Now it's in your hands, a half-friendly Frankenstein monster making its way in a world filled with remainder bins and crafty discount booksellers.

There are those who insist that opposites attract, but it is best to avoid this advice in most real-life situations, especially those involving electricity. The results can be explosive, and are best contained in the pages of a book.

You can compare *Bricksy*'s LEGO street art with thumbnail photos of Banksy's originals throughout these pages. Complete photographer credits for the thumbnails are found in the legend section beginning on page 111. If you are inspired to make your own LEGO street art, remember to ask permission from the LEGO brick owners, or at least wait until they are safely distracted at their kindergarten class.

THIS BOOK CONTAINS

This site contains blocked messages

BRICKED MESSAGES

The trouble
with the human
race is that
even if you
win, you're
still a human.

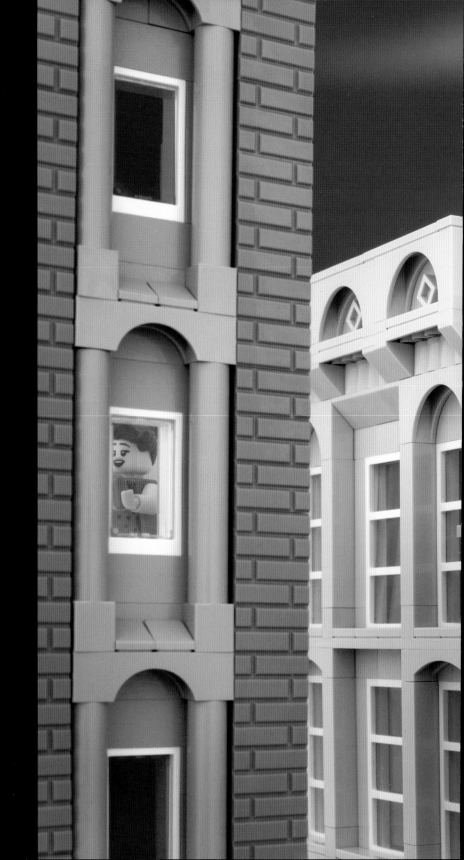

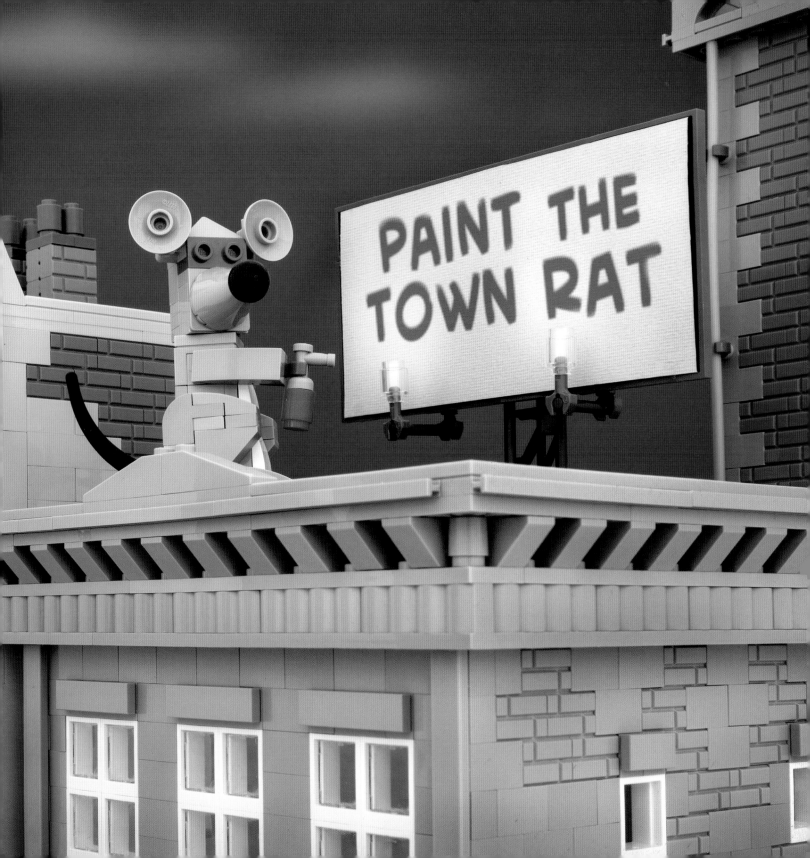

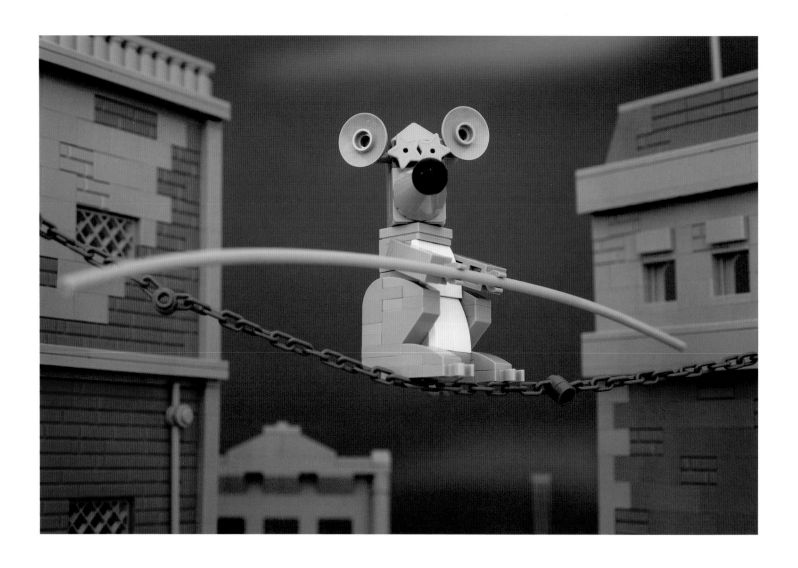

Rats may live in the gutter, but some are looking through the stars.

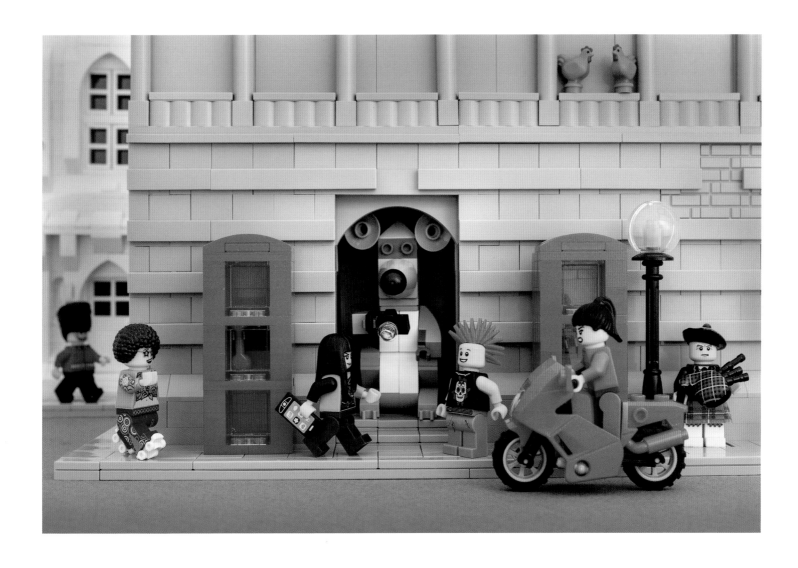

Pack rats hoard photographs for later viewing rather than living in real time.

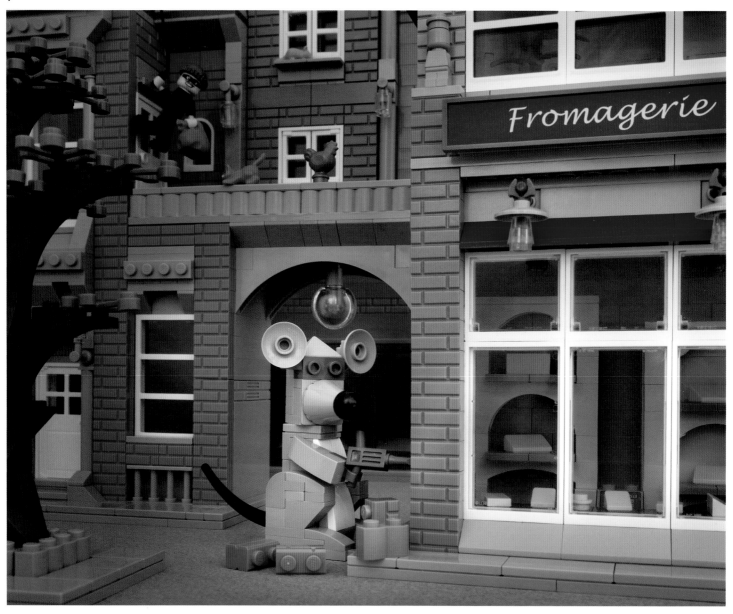

Not every rat can fit through a hole the size of a quarter.

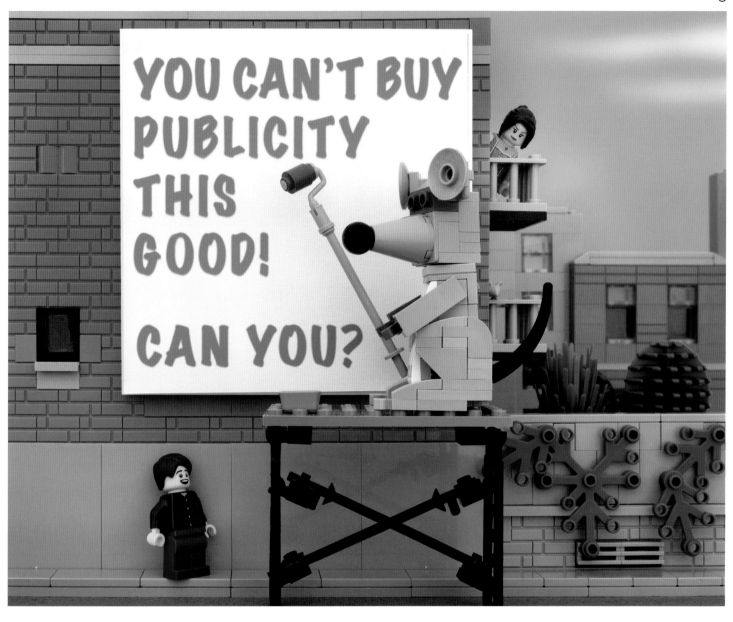

Vermin know it pays to advertise.

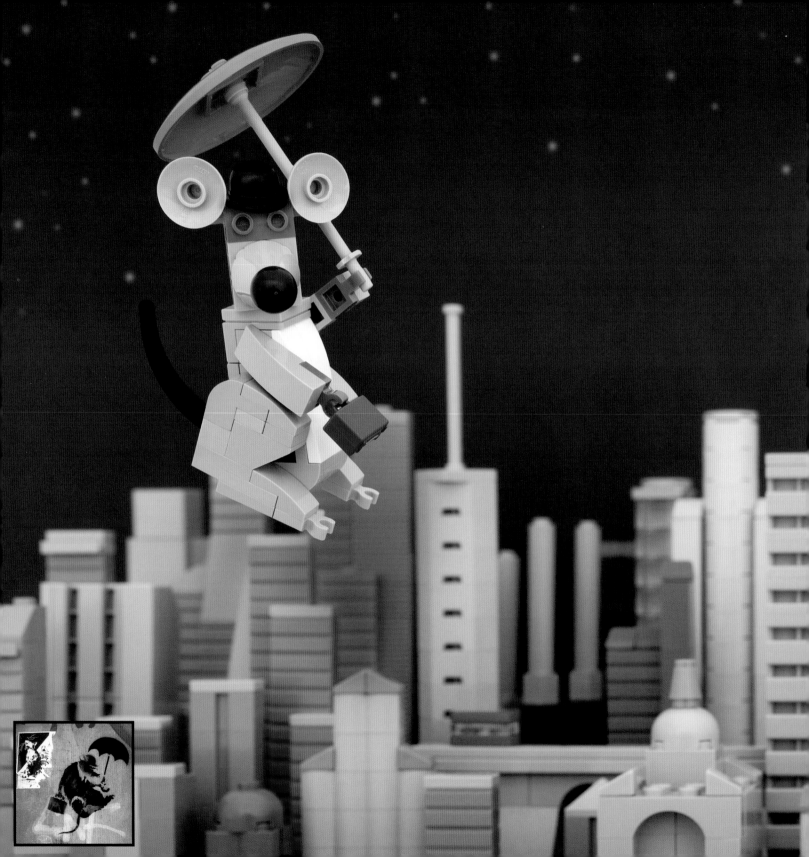

Mousy Poppins loves a cheesy musical.

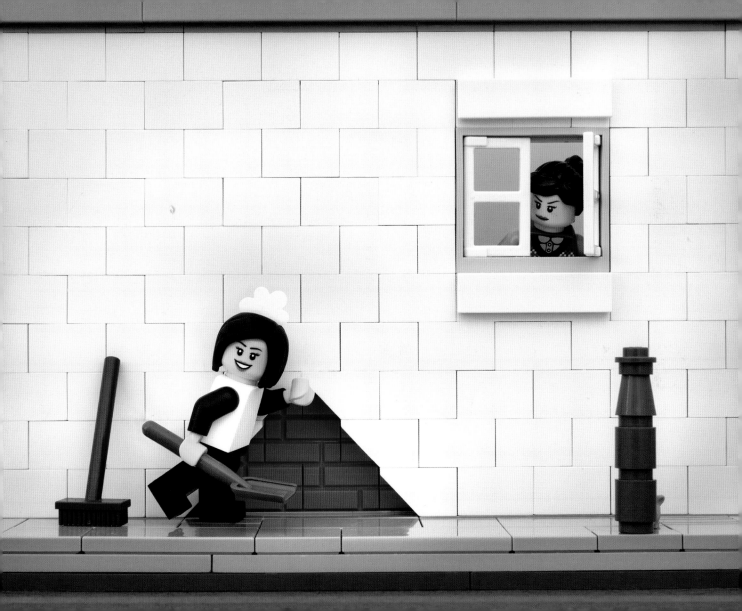

Tighty-whities wouldn't
have been Stanley's first
choice for public display.

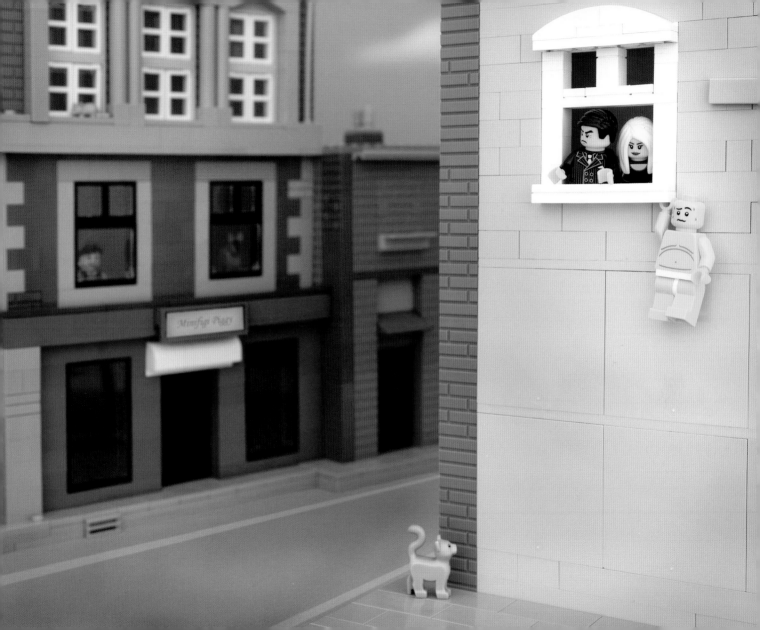

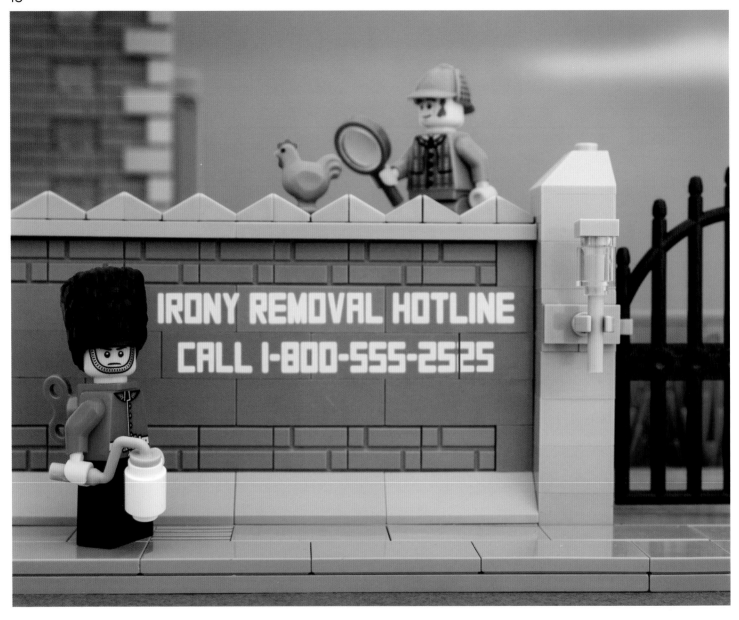

IRONY REMOVAL HOTLINE
CALL 1-800-555-2525

For those who don't understand irony, Sherlock Holmes and the mysterious hen are provided for your amusement.

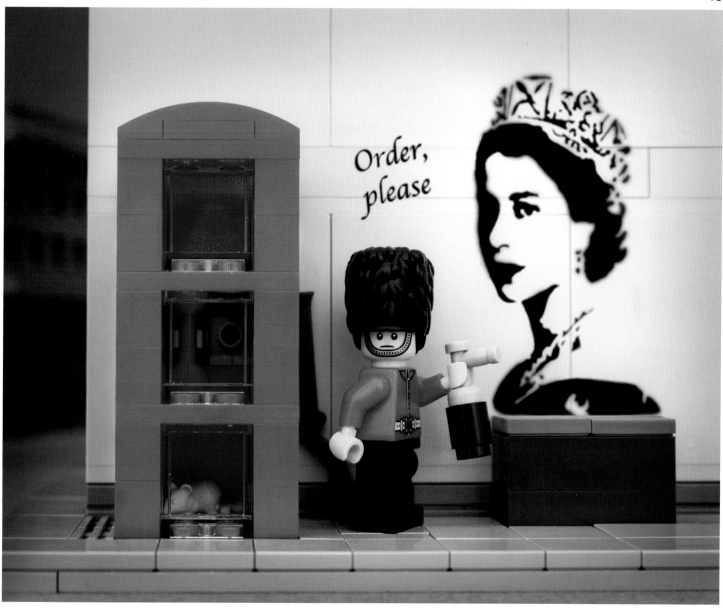

The Queen's secret Royal Stencil Regiment keeps order with experimental methods.

but you're paying
cup of coffee.

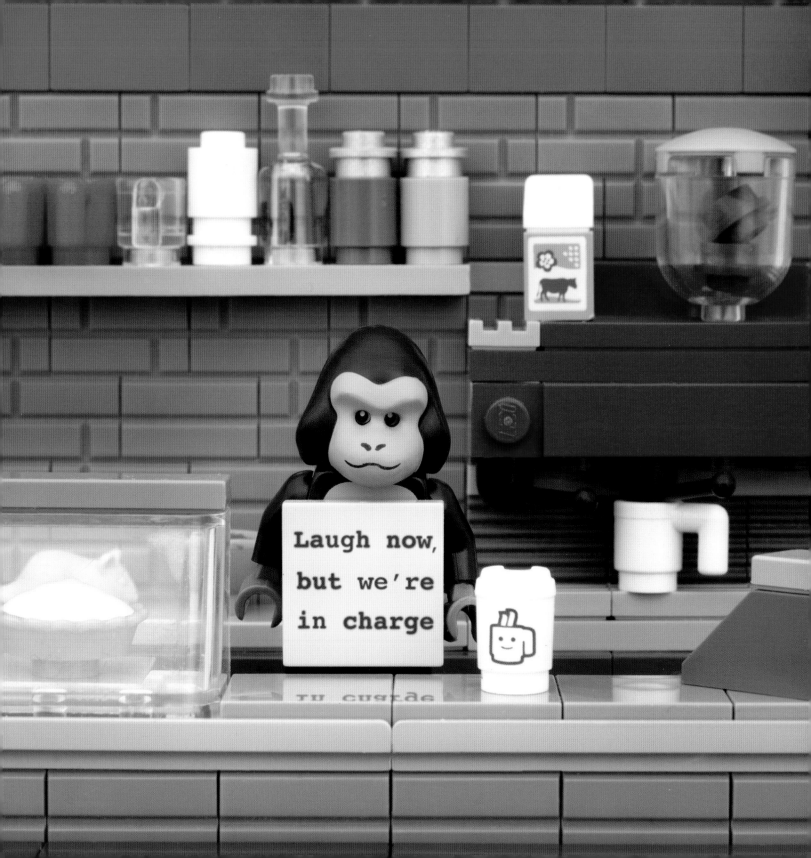

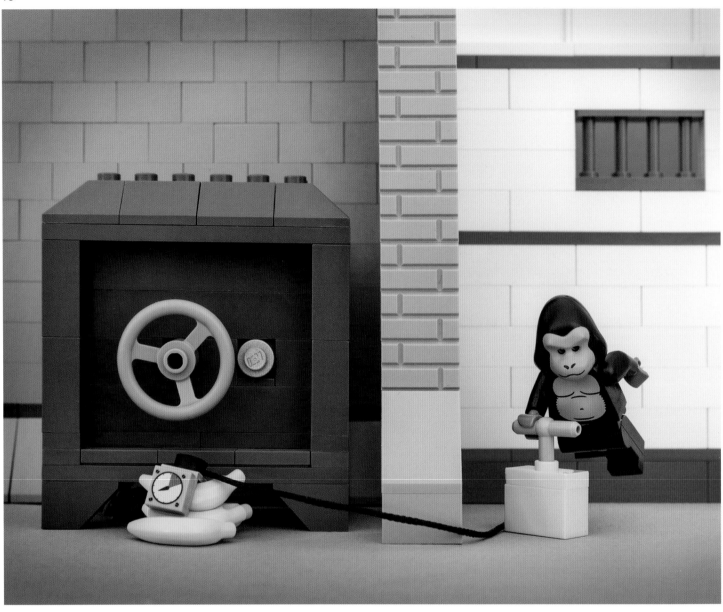

One way of making bananas split.

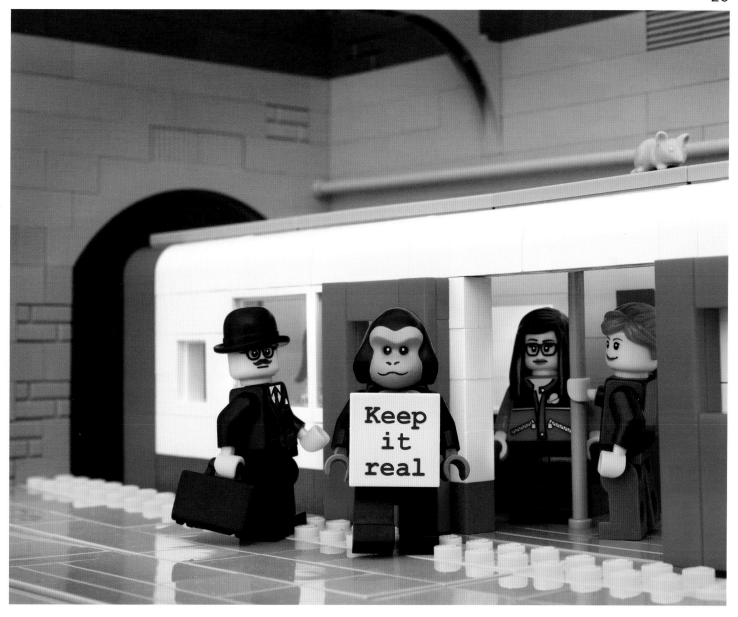

Ninety-eight percent of being human is suppressing your inner monkey.

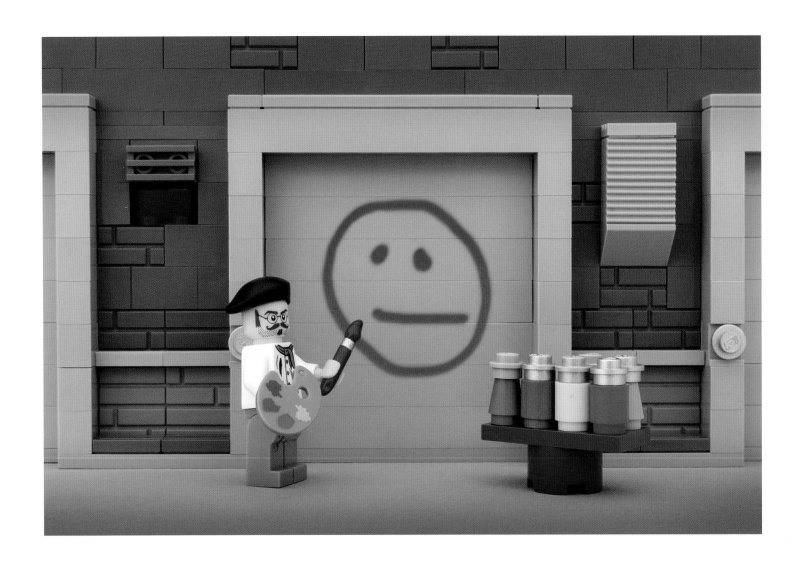

Ideas are more important than artistic talent.

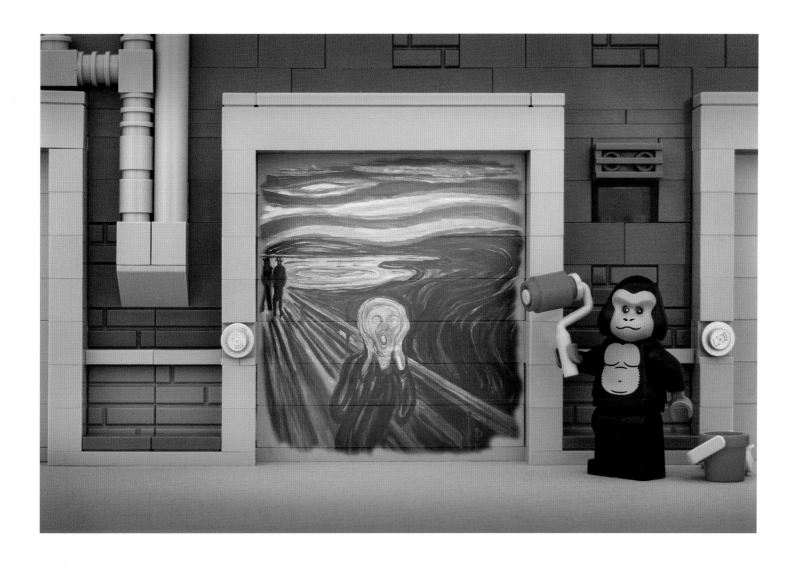

Bad artists imitate. Great artists steal. Great apes know they can't be sued for copyright infringement.

Forbidden love flower delivery.

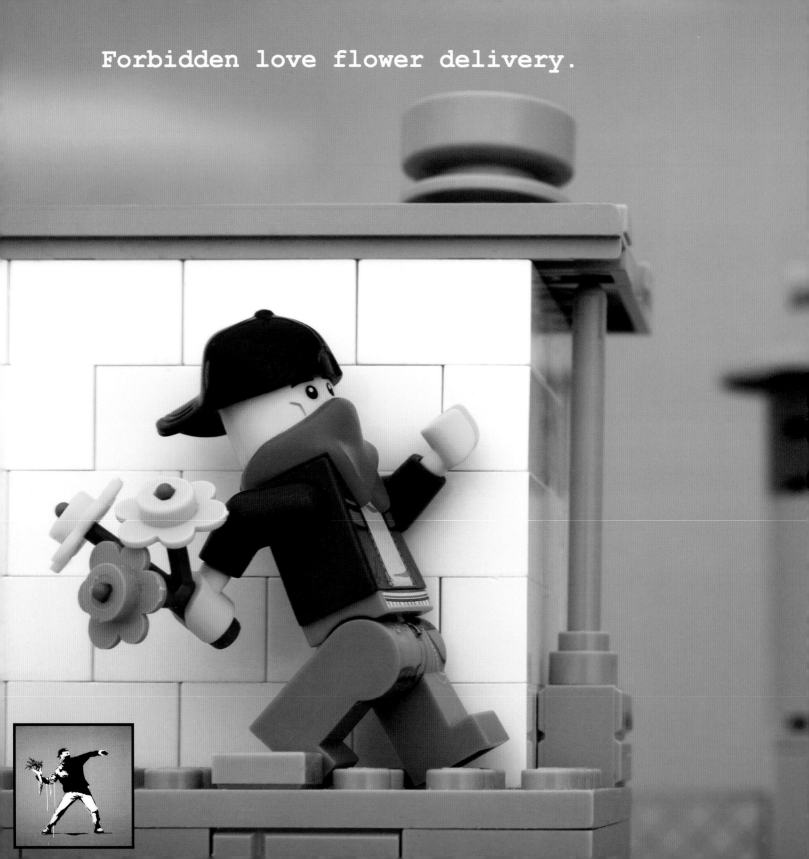

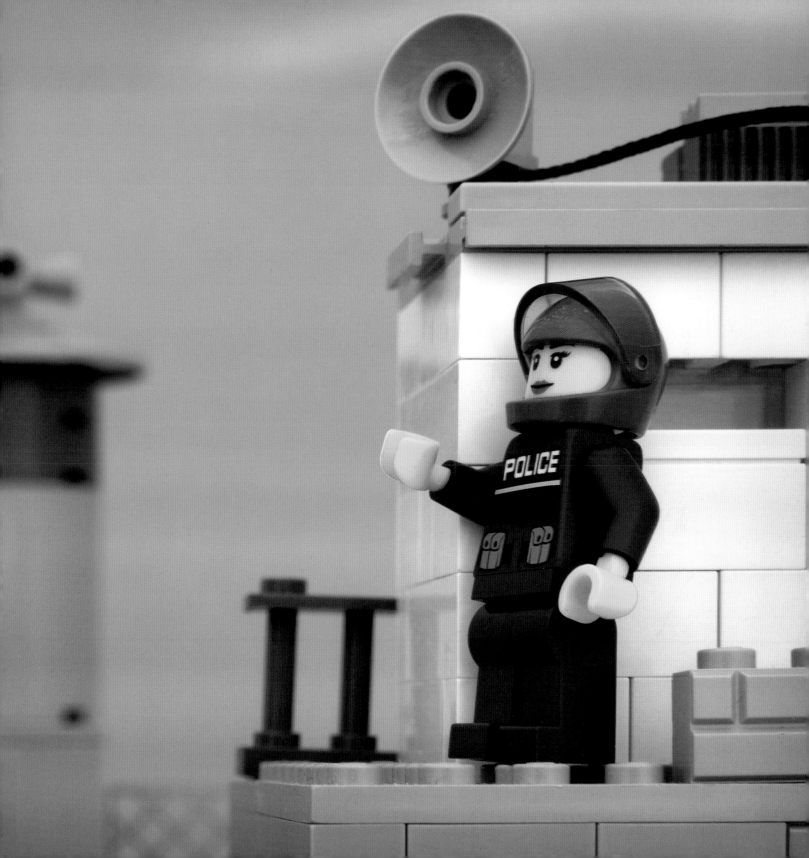

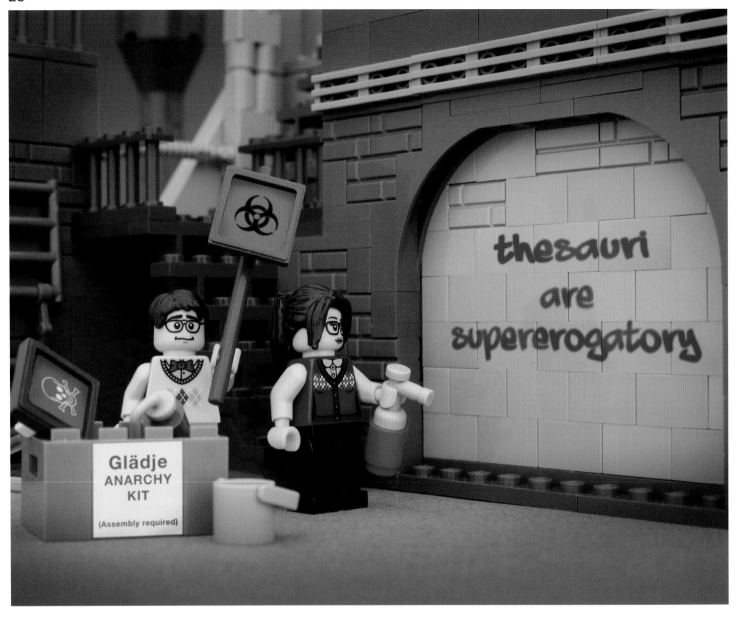

Street art still has its edge, according to Molly and Larry Patterson.

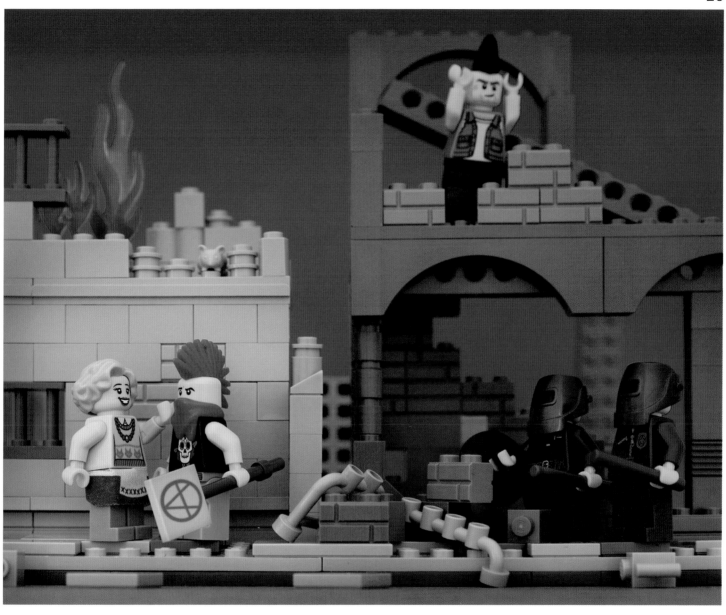

Betty Smith, the mother of anarchy.

It's important
for kids to
get some
fresh air.

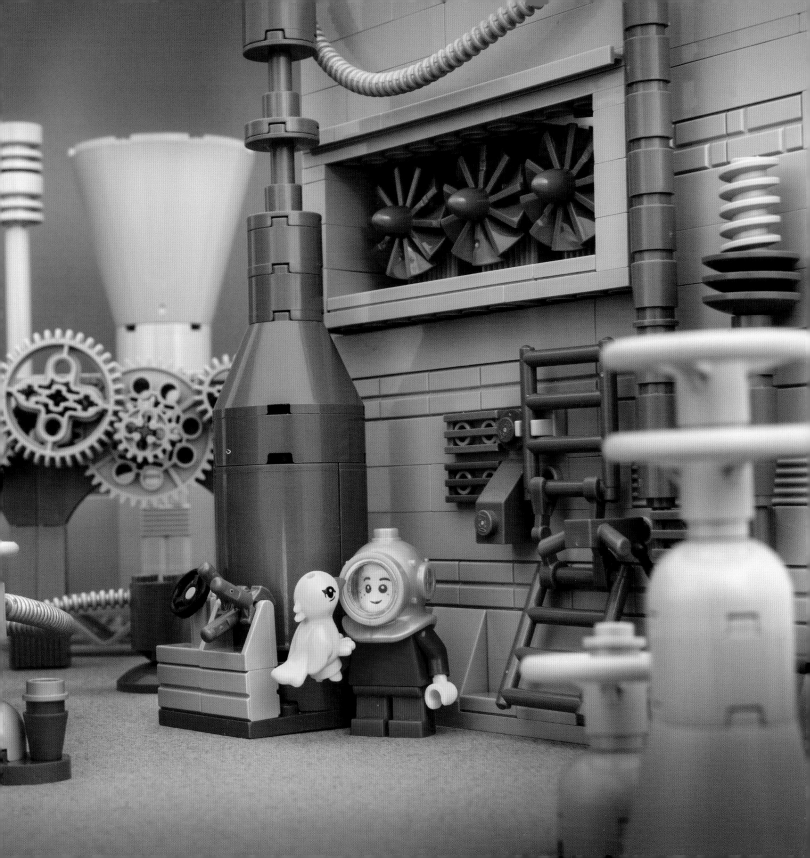

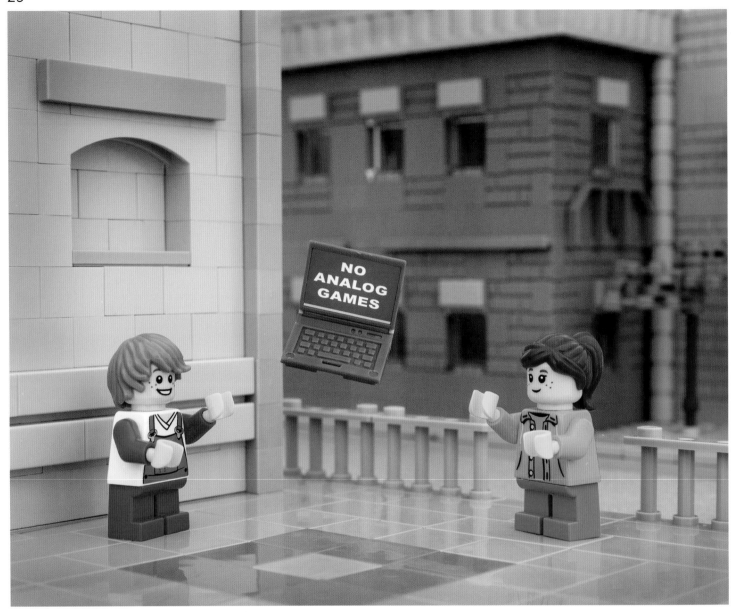

Two can play at this game.

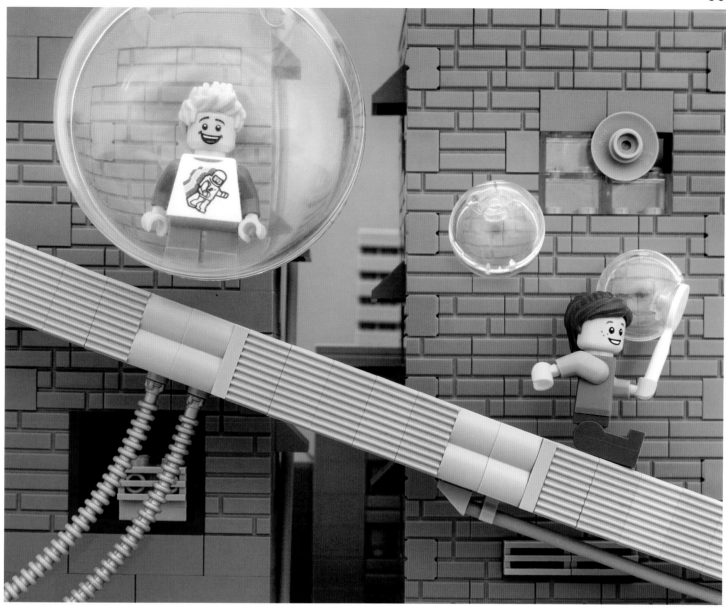

People talk about living in a bubble as if it were a bad thing.

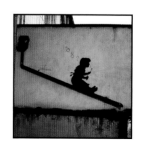

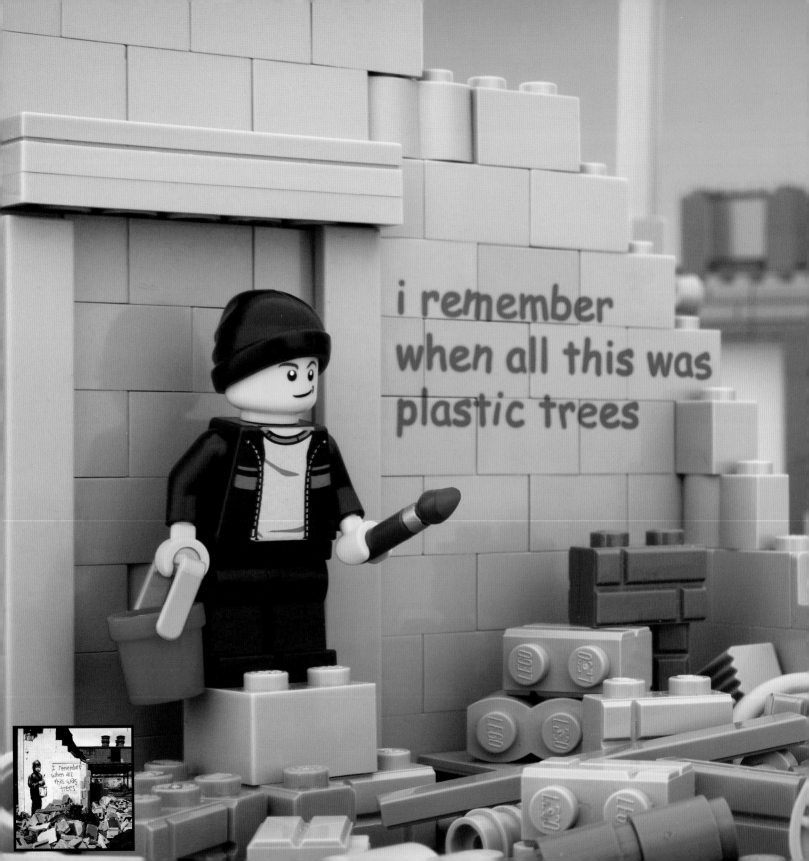

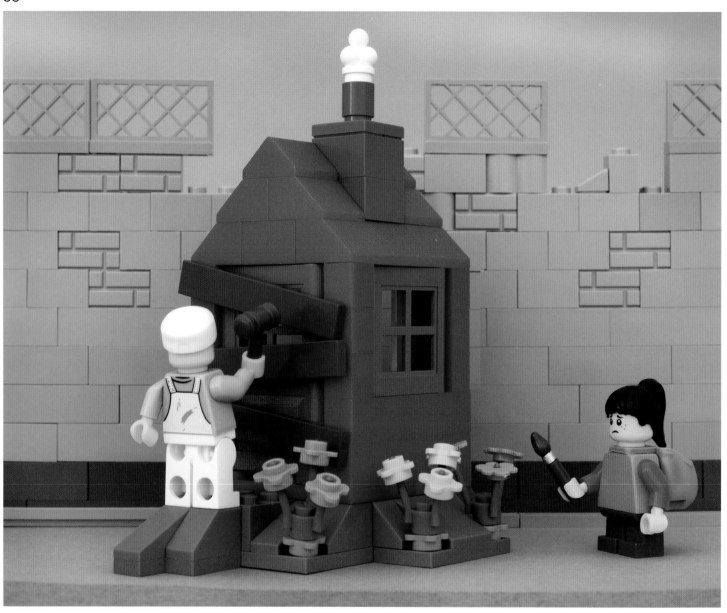

Daydreams are delightful . . .

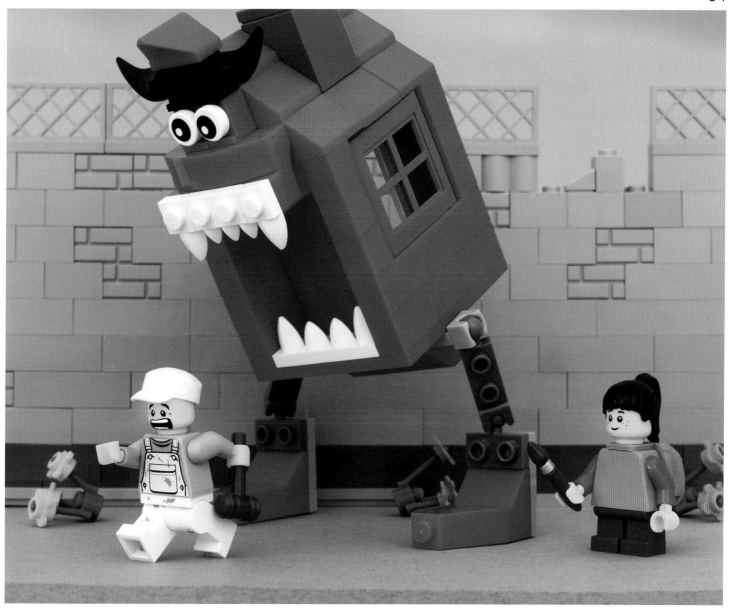

. . . but nightmares can also be put to good use.

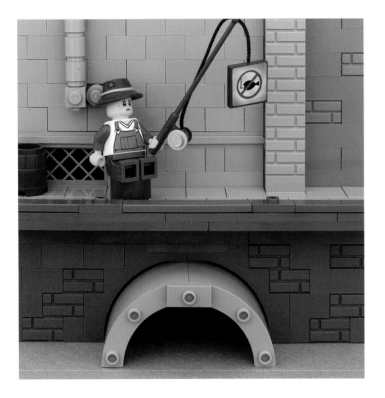

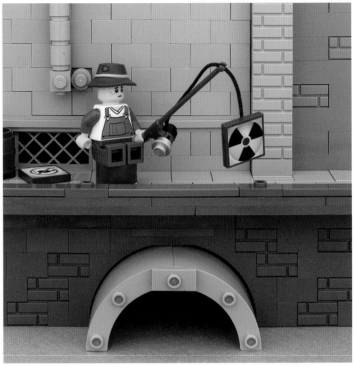

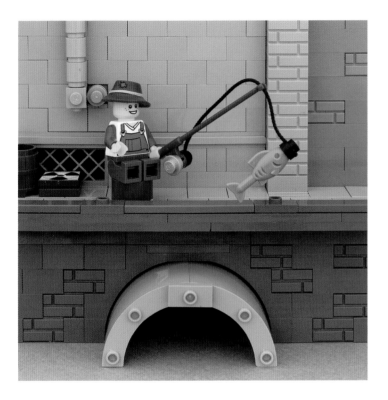
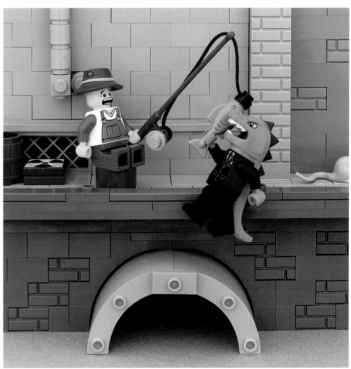

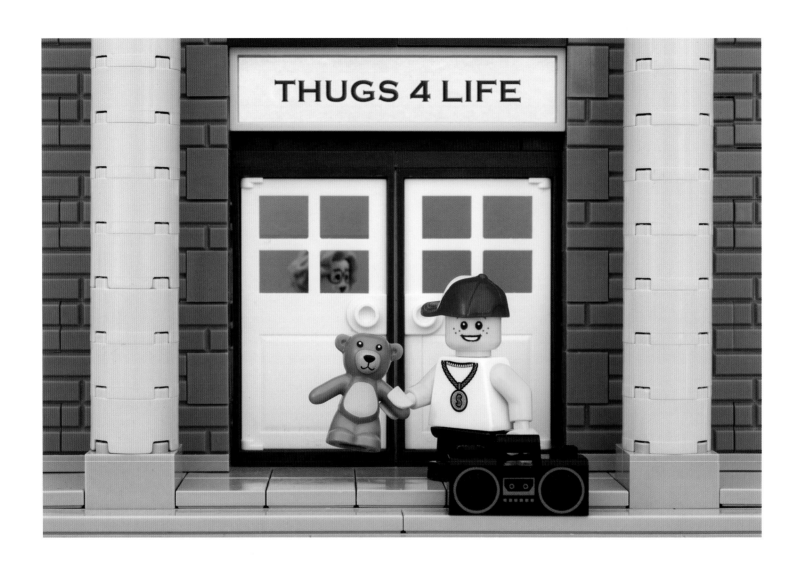

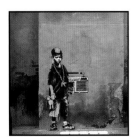

Always nurture your children's talents.

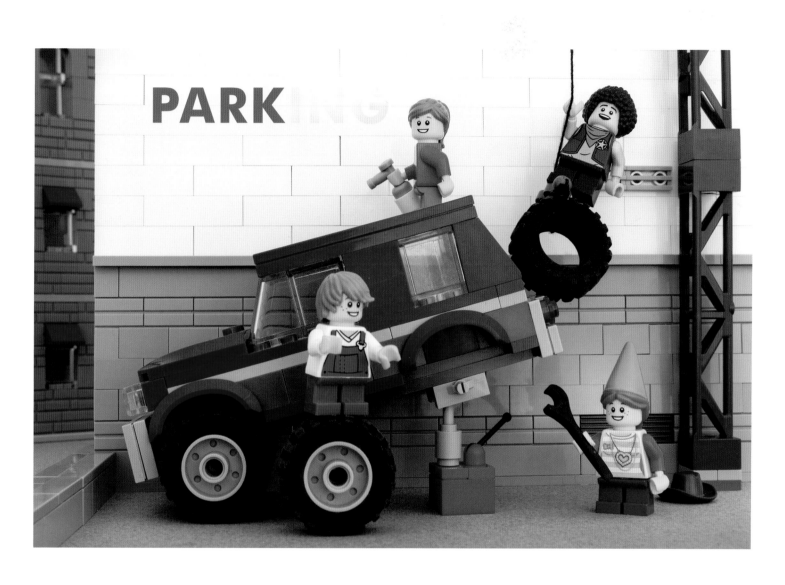

It's amazing what kids can do with just a wrench, some spray paint, and a sunny afternoon.

The police's "stop and frisk" policies are widely misunderstood.

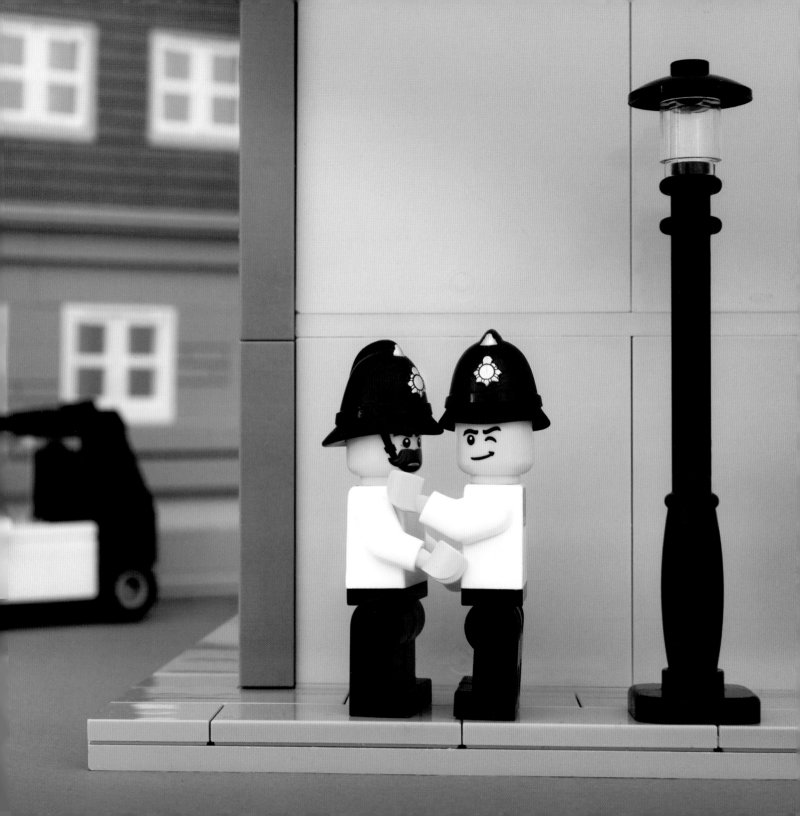

Painting is the most powerful art form, provided that you work for the Department of Transportation.

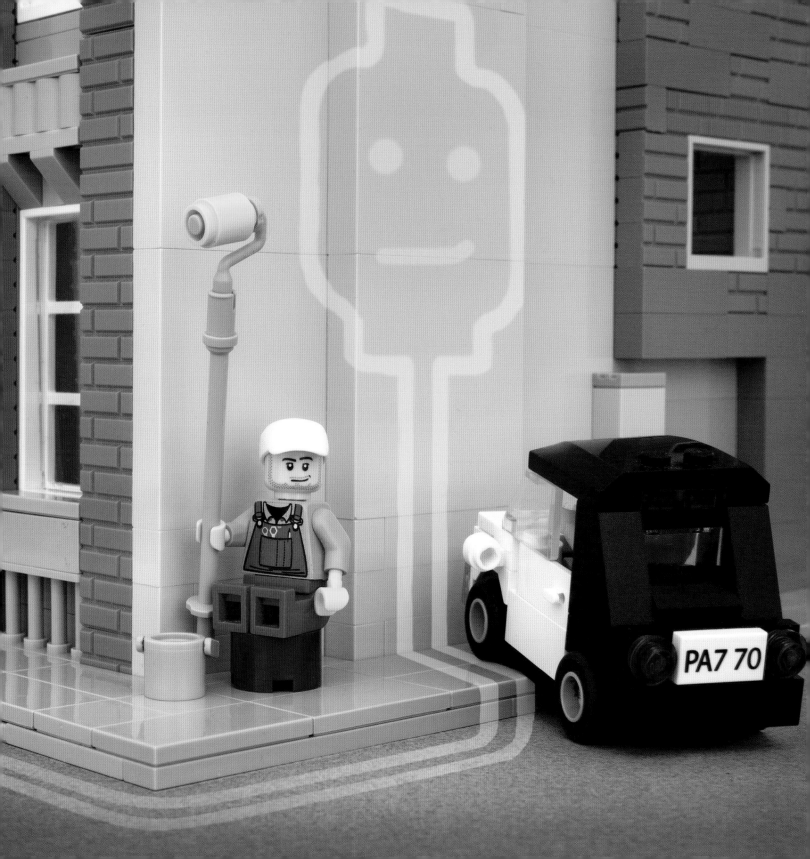

The secret to great book design

The key to making great art is all in the compositio

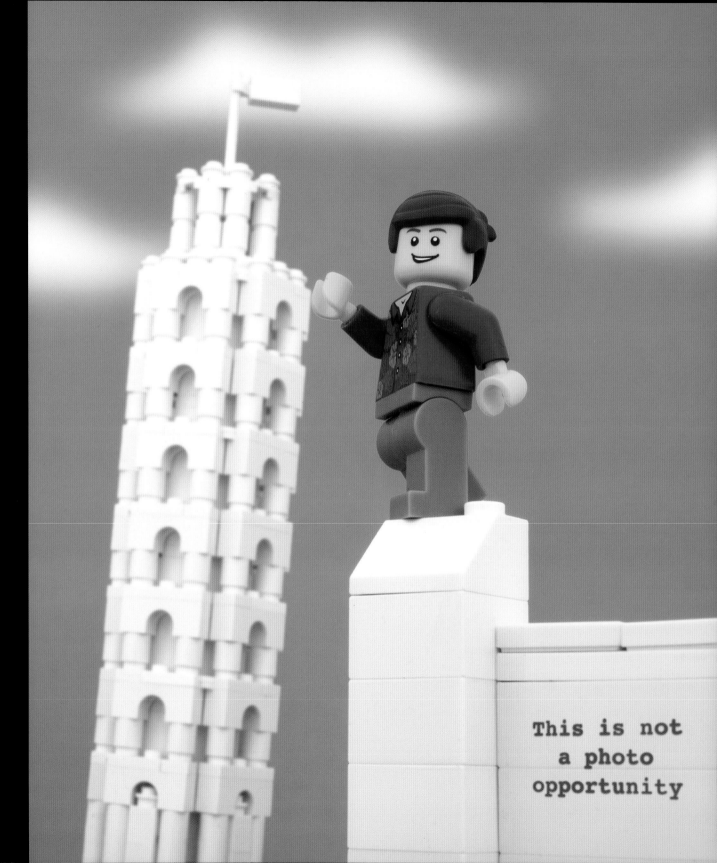

This is not
a photo
opportunity

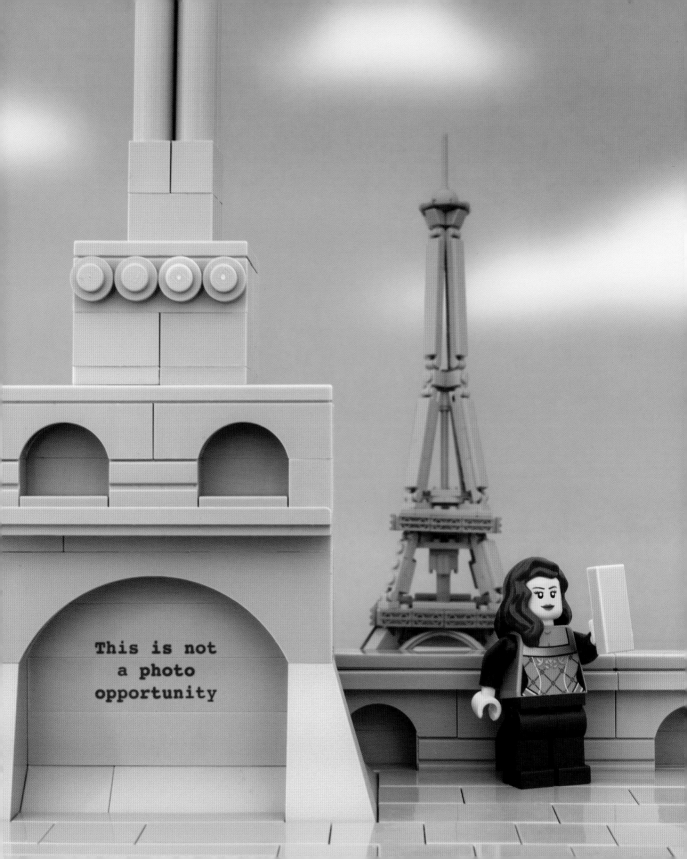

This is not
a photo
opportunity

It has never been easier to be a tourist in other people's fake realities.

This is not
a photo
opportunity

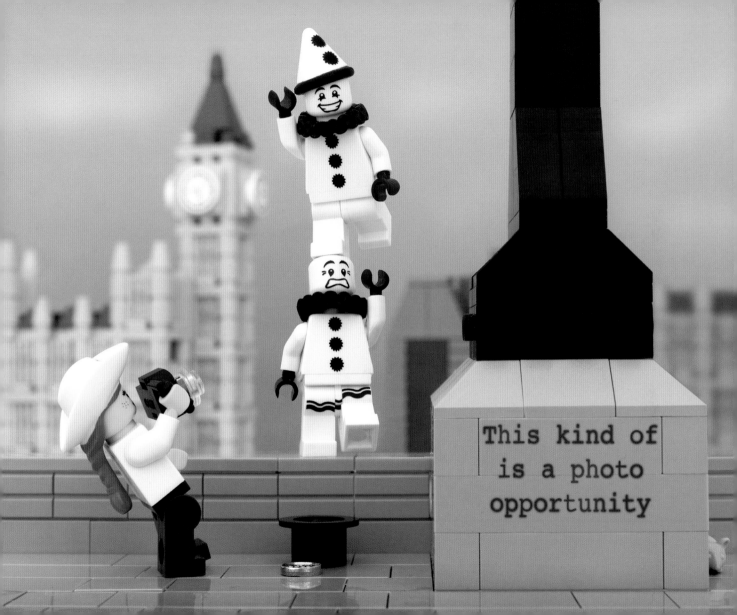

This kind of is a photo opportunity

Tune in, turn
on, drop it out.

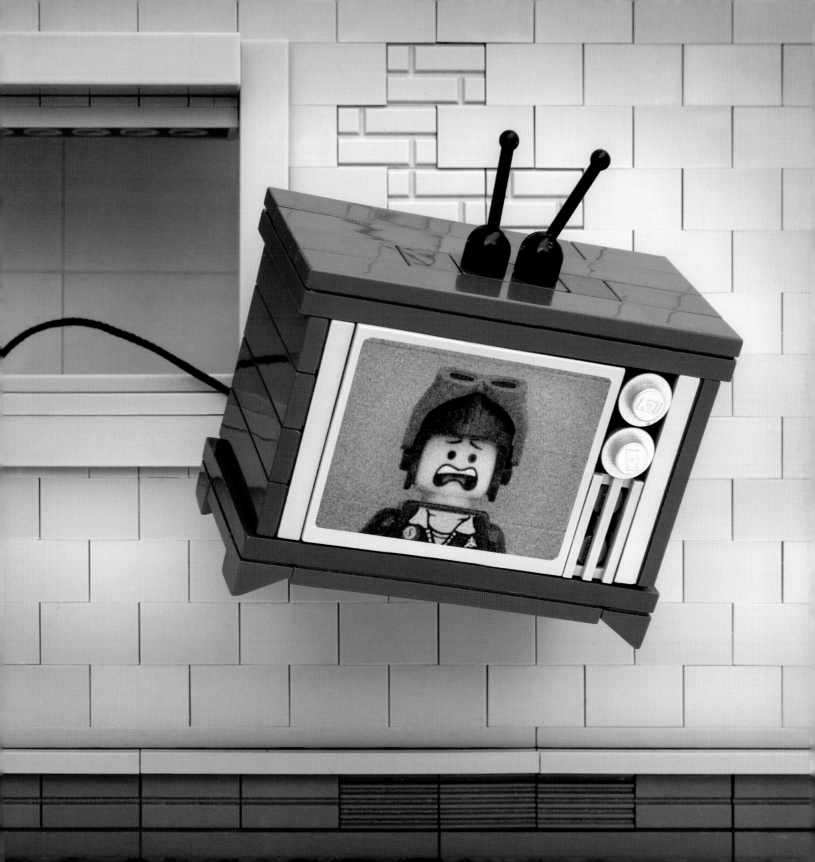

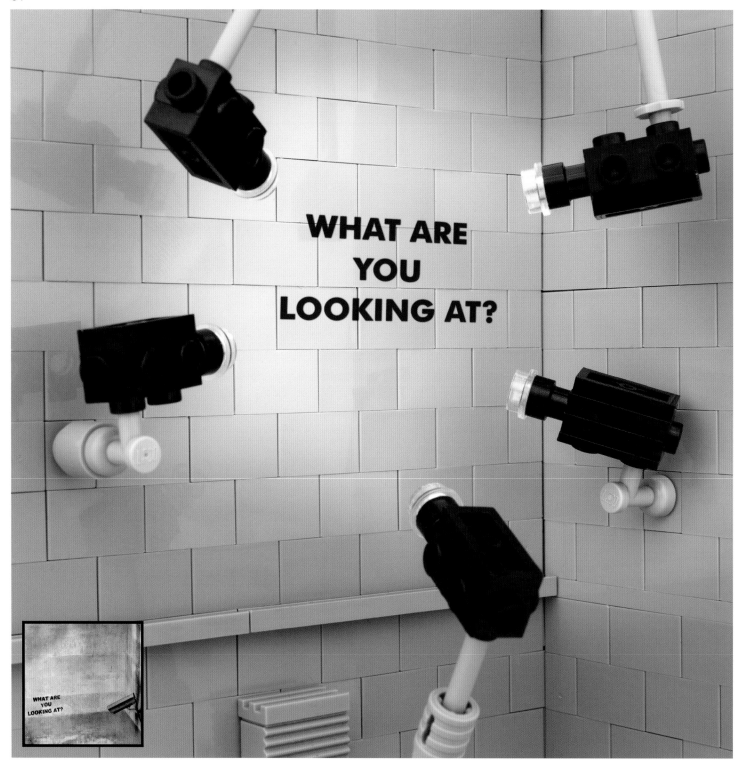

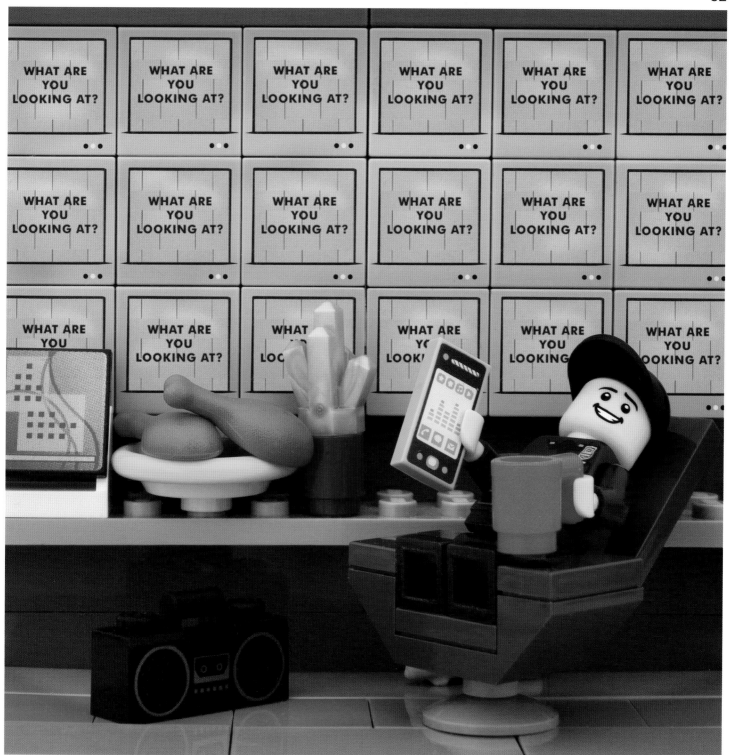

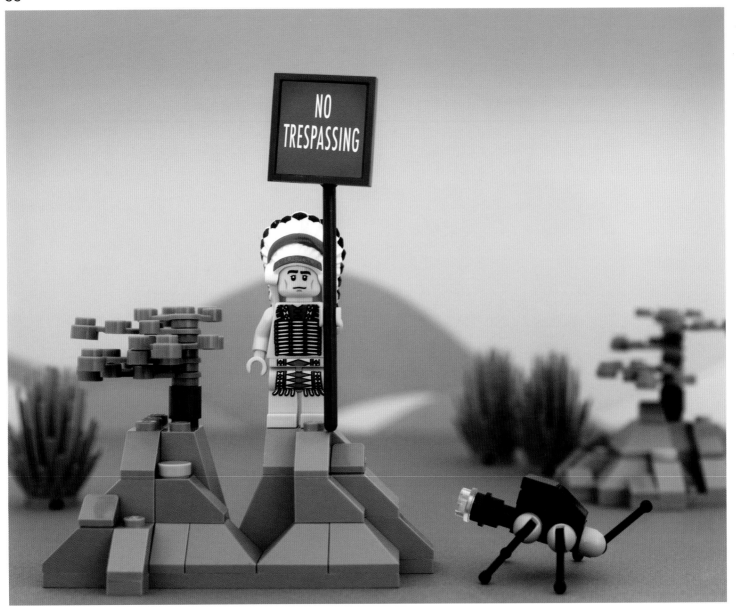

It's a sign of the times.

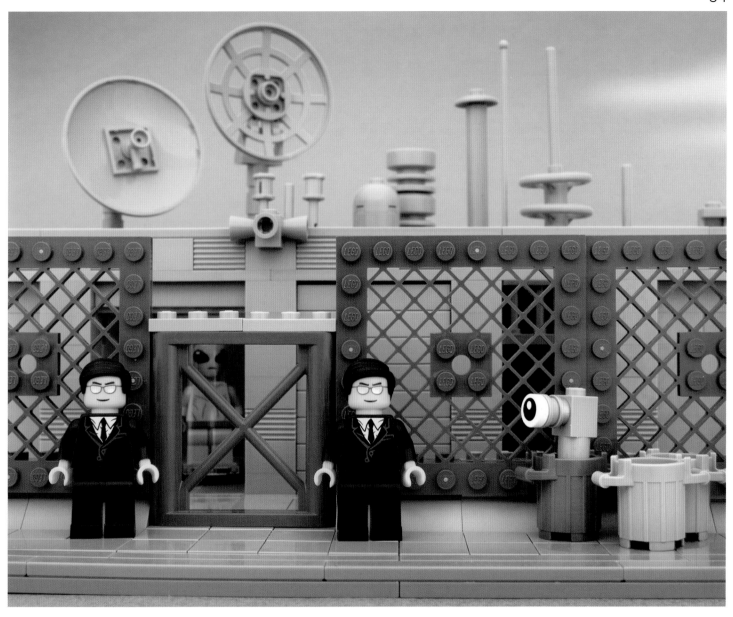

The conspiracy theory of evolution.

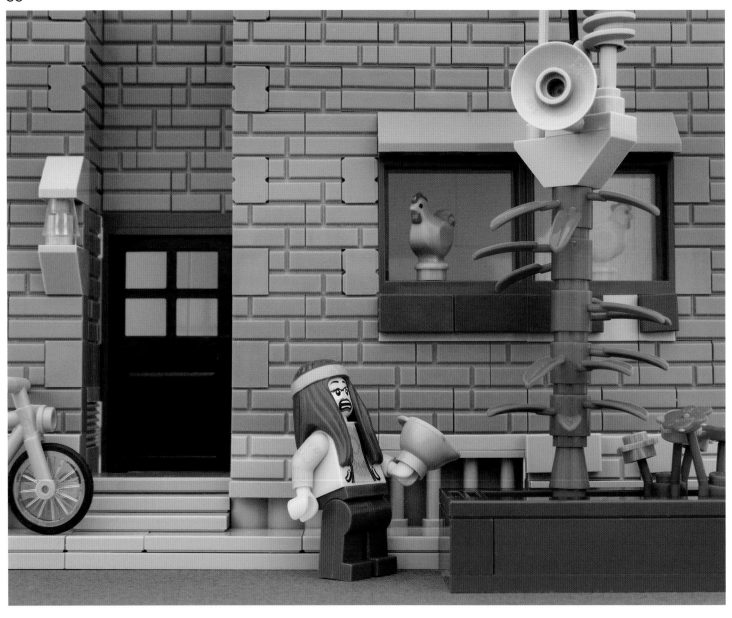

Invasive species spread quickly if left unchecked.

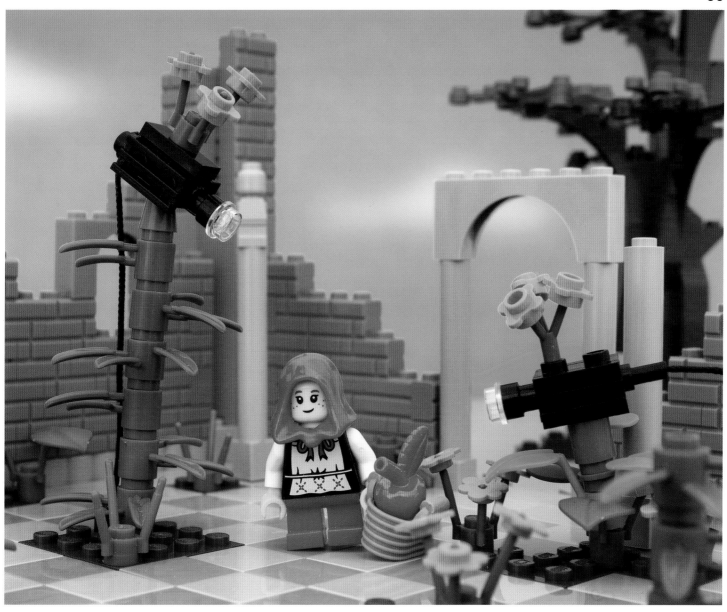

Ever get the feeling you're not being watched?

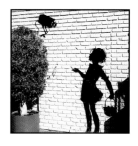

Manufacturing drama is a
growth industry.

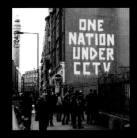

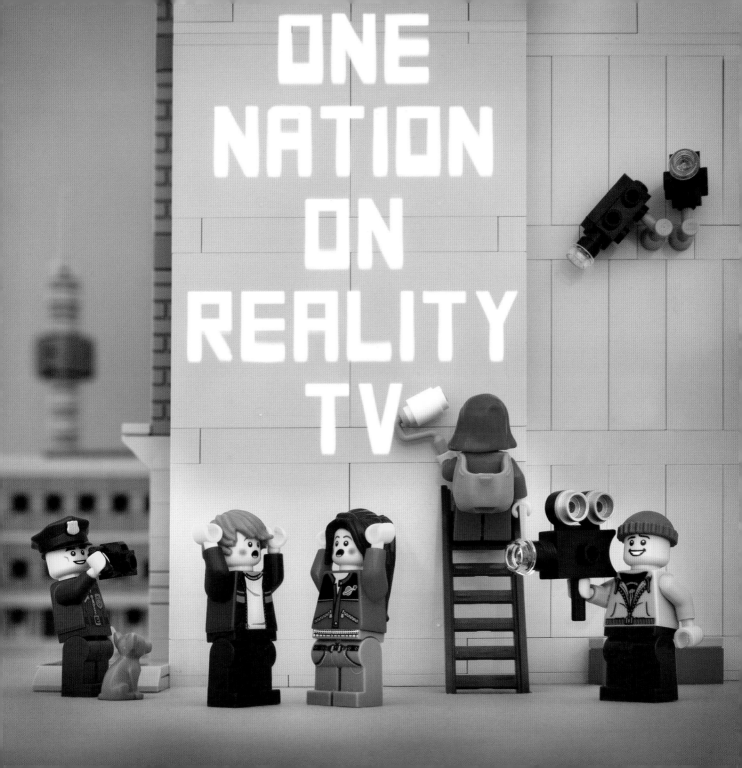

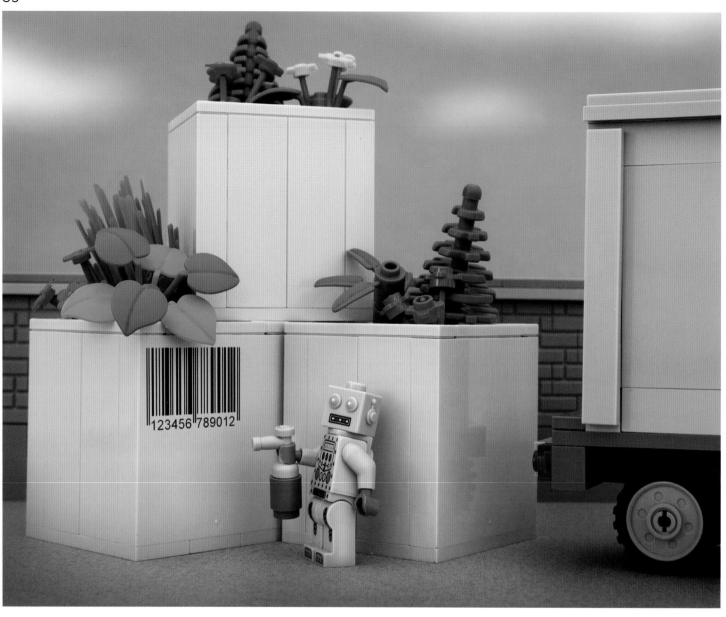

Buy now and pay later; everything's on sale.

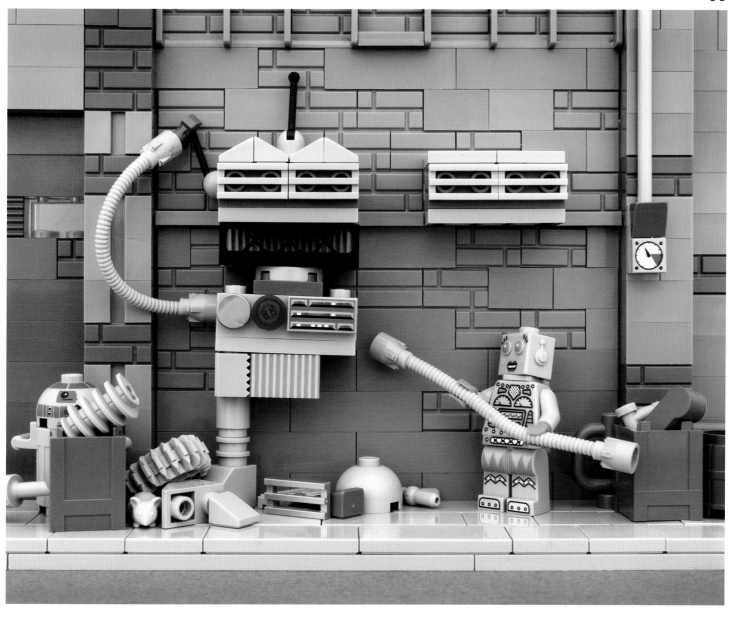

For some people, making friends is easy.

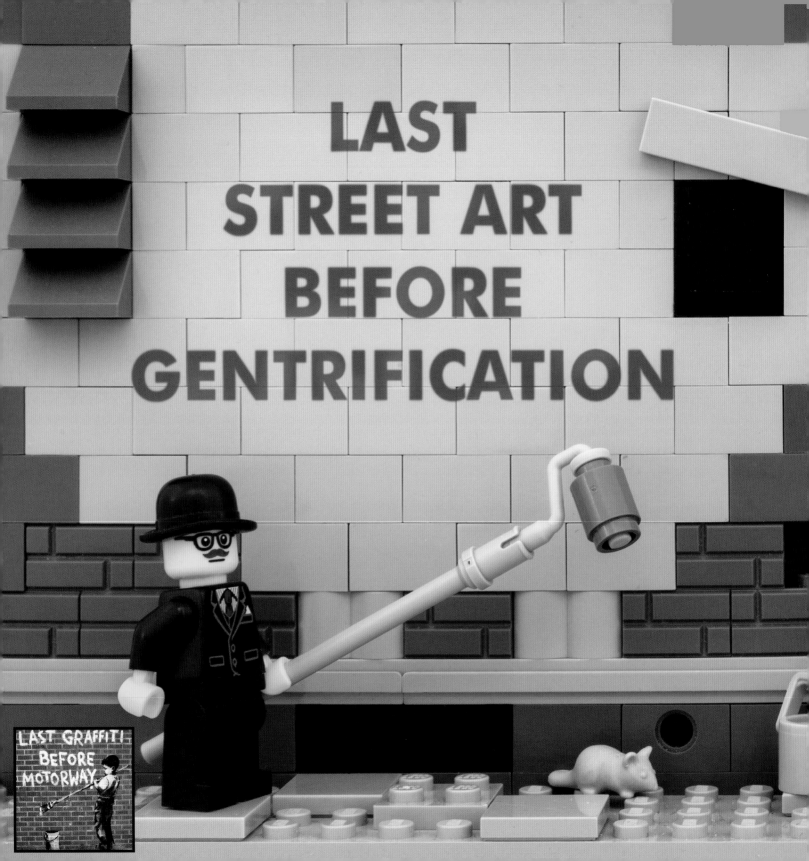

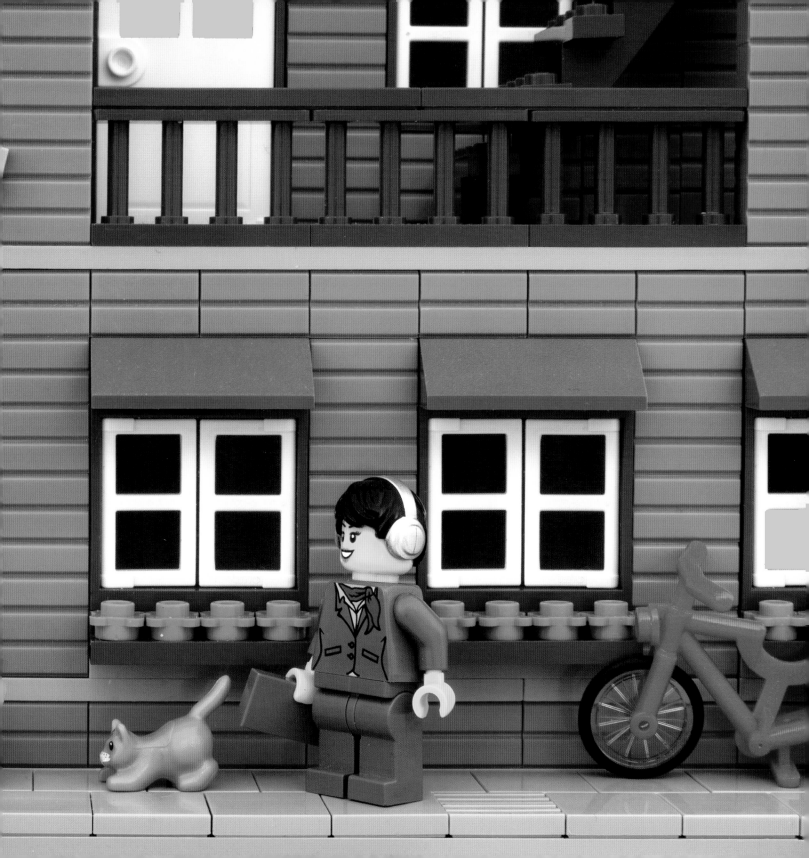

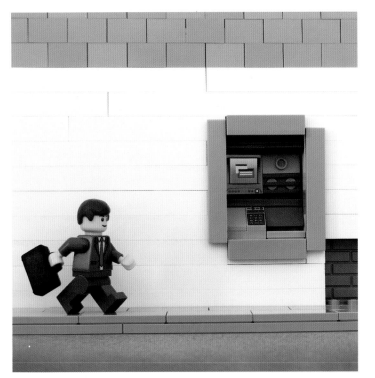

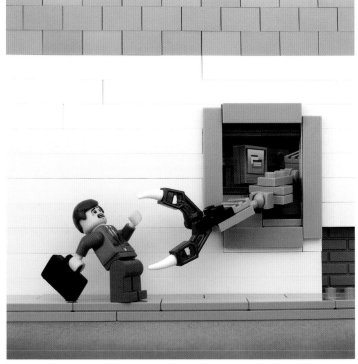

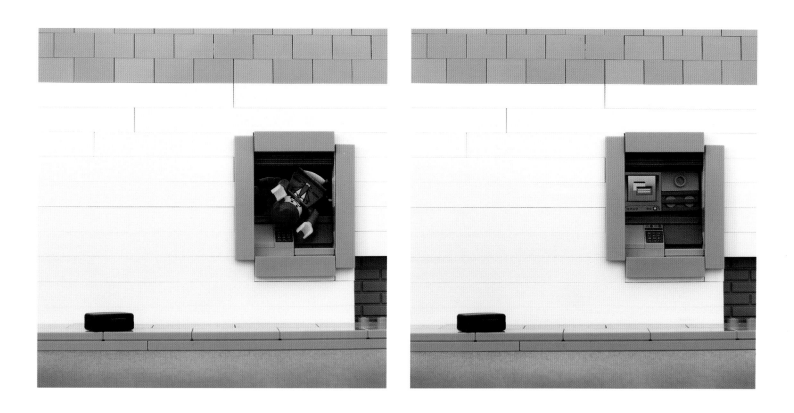

Going into withdrawal.

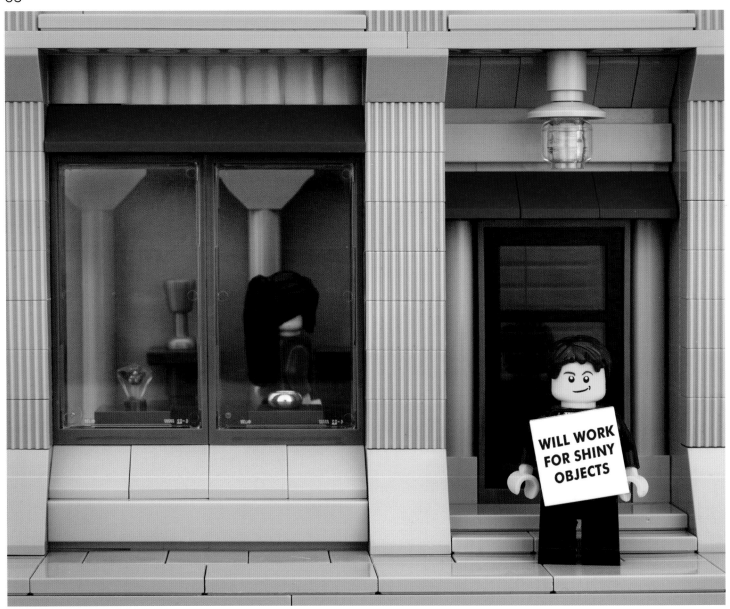

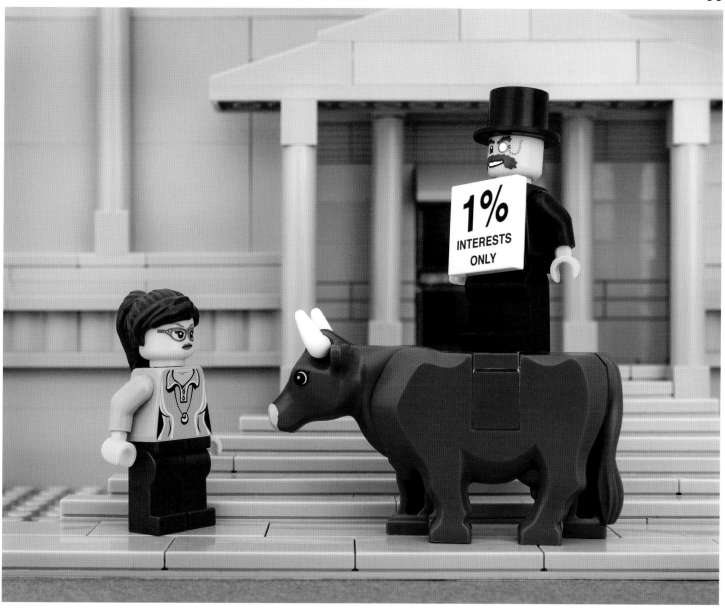

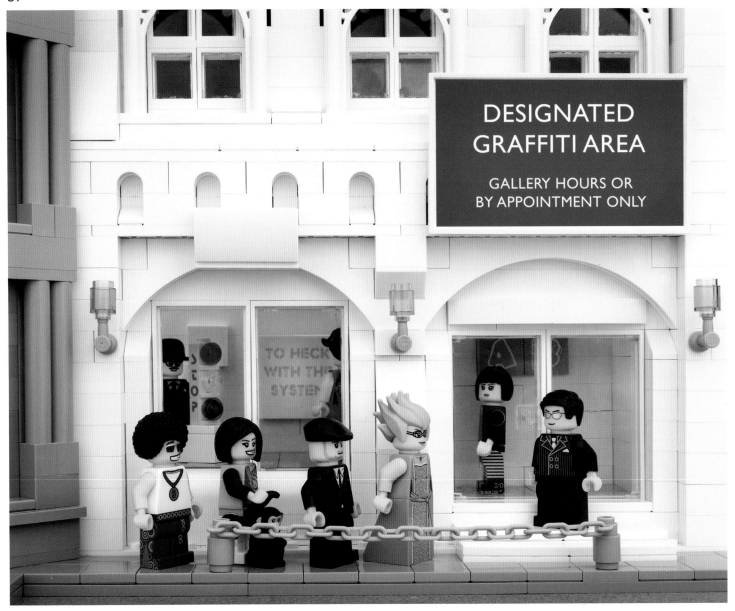

DESIGNATED
GRAFFITI AREA

GALLERY HOURS OR
BY APPOINTMENT ONLY

Every town has its sketchy areas.

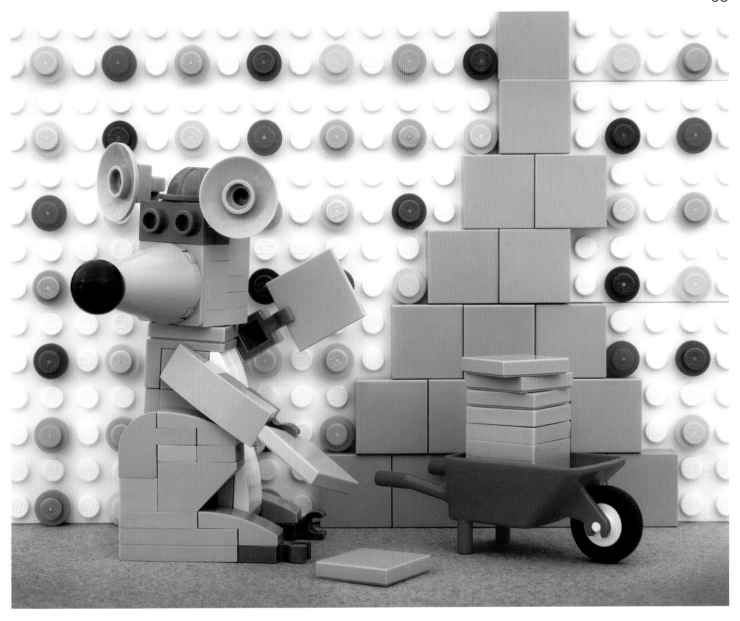

Bricked Damien Hirst. Limited-edition prints are available
for $37,000,000.

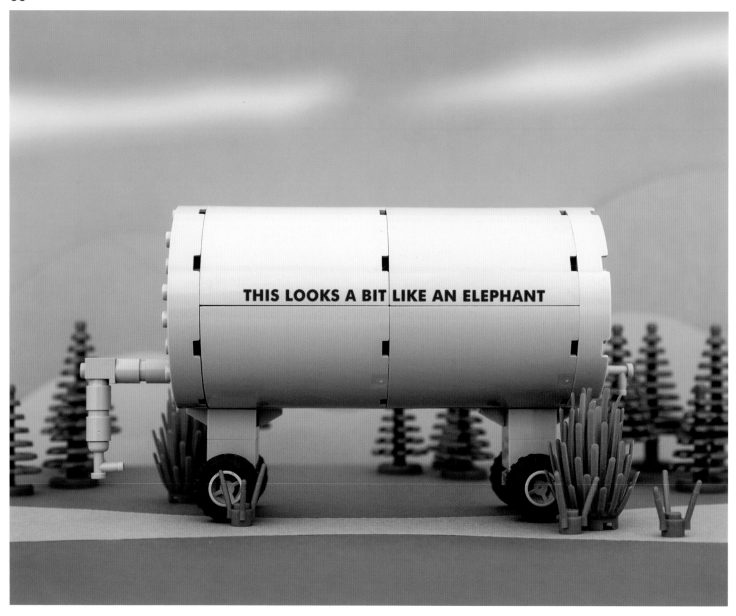

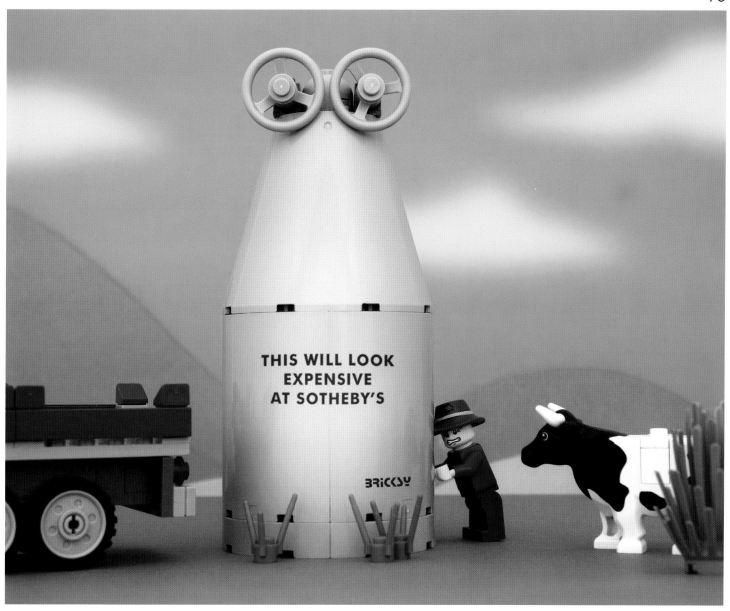

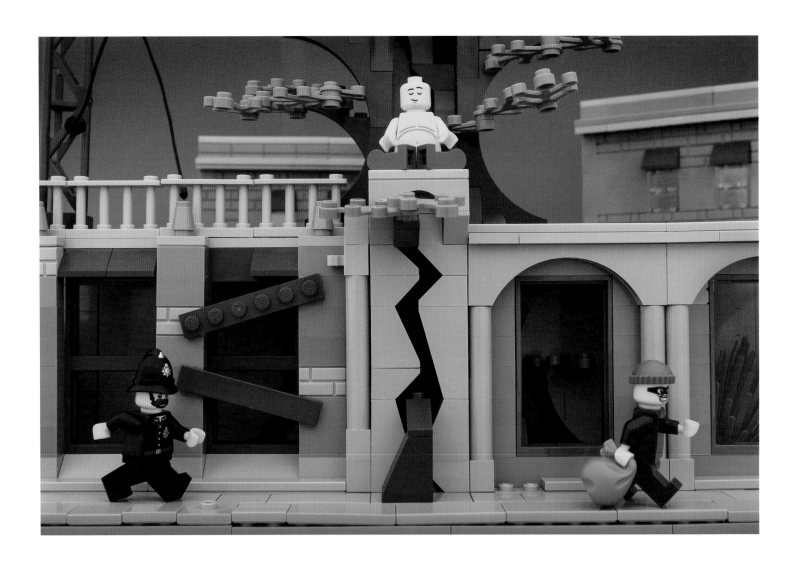

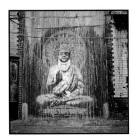

The secret to bliss is denial.

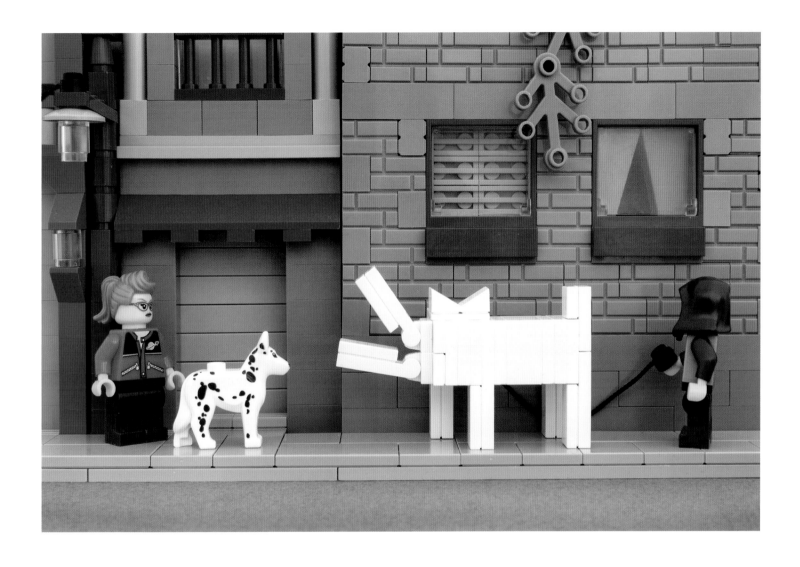

Keith Haring's successes as a dog breeder are overshadowed by his artistic accomplishments.

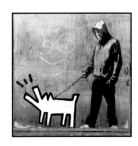

The floral industrial complex leads
to an endless cycle of goodwill.

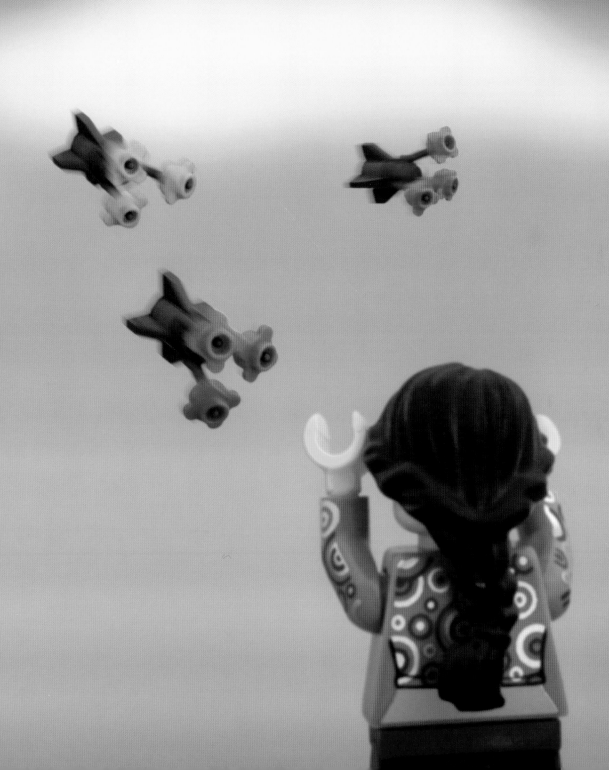

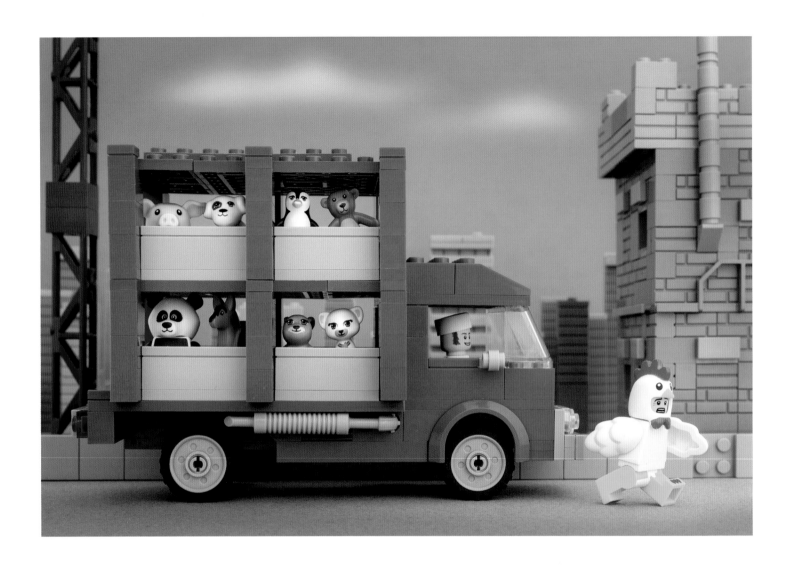

Why the chicken crossed the road.

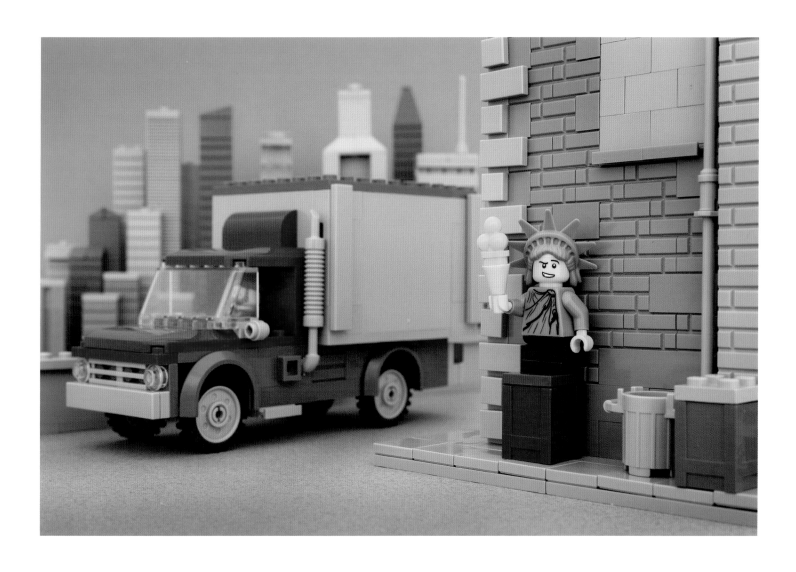

Give me liberty or give me ice cream topped with butter.

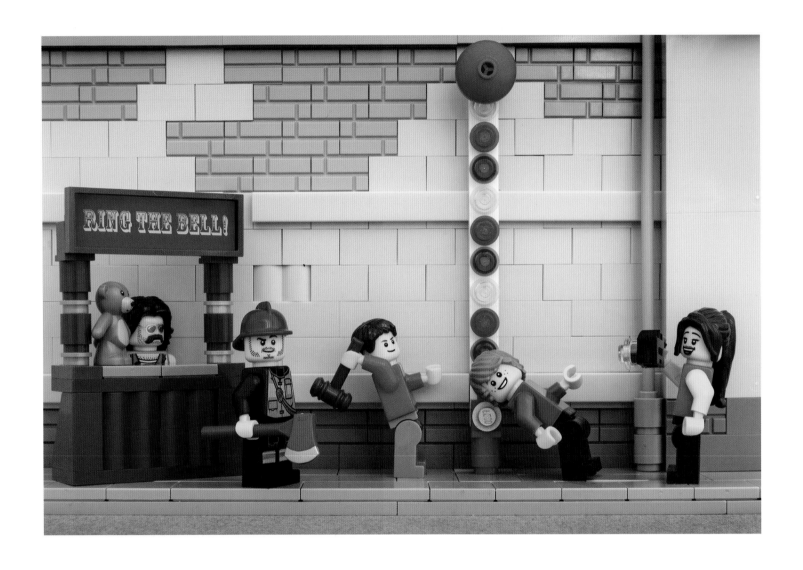

Nothing in firefighter training prepares you for how weird people can be.

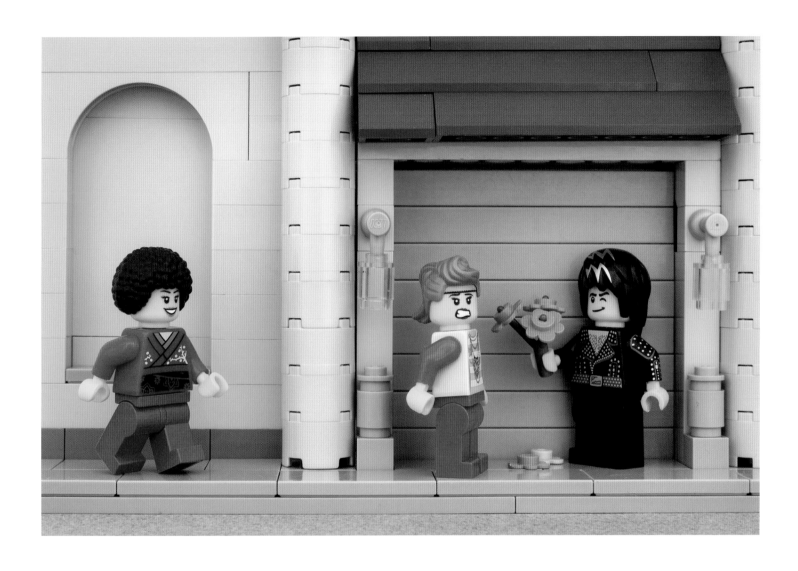

Randy is a hopeless romantic.

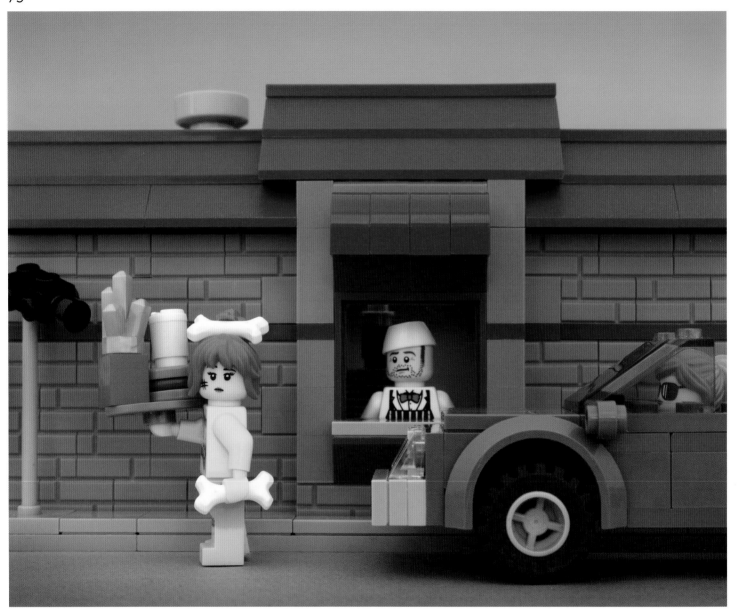

The real Paleo diet: eating sugar, carbs, and mystery meat
whenever they cross your path.

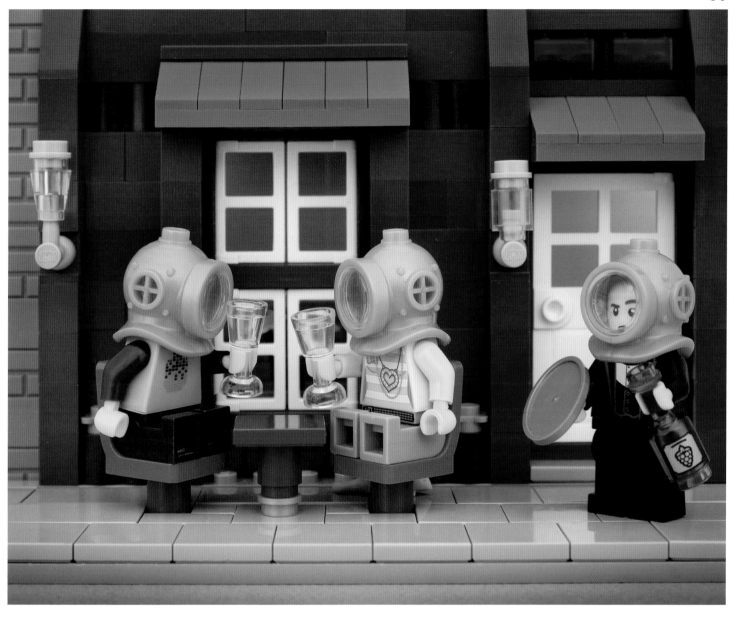

It's prudent to wear full protection on a first date.

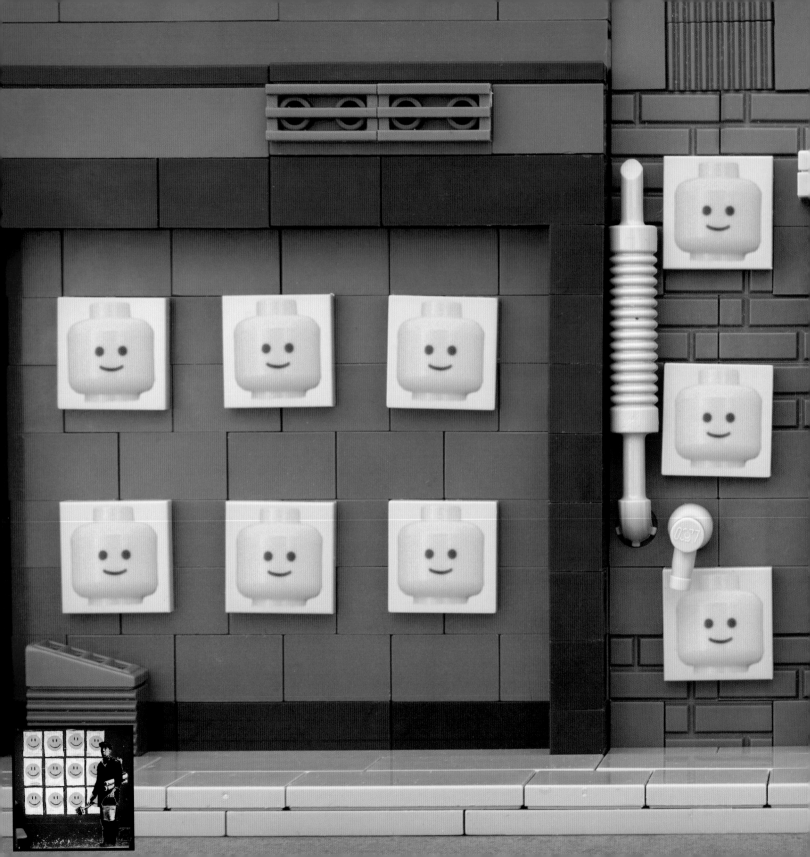

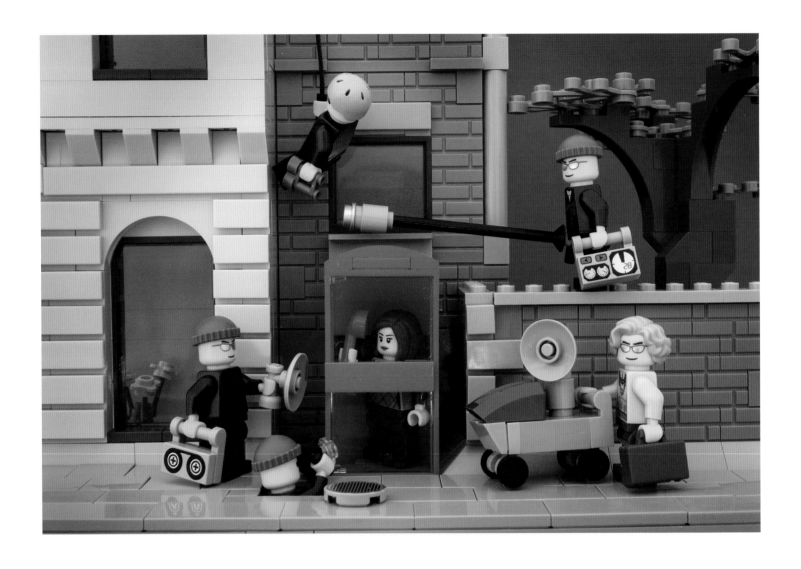

Thank you for waiting. Your call is strangely important to us.

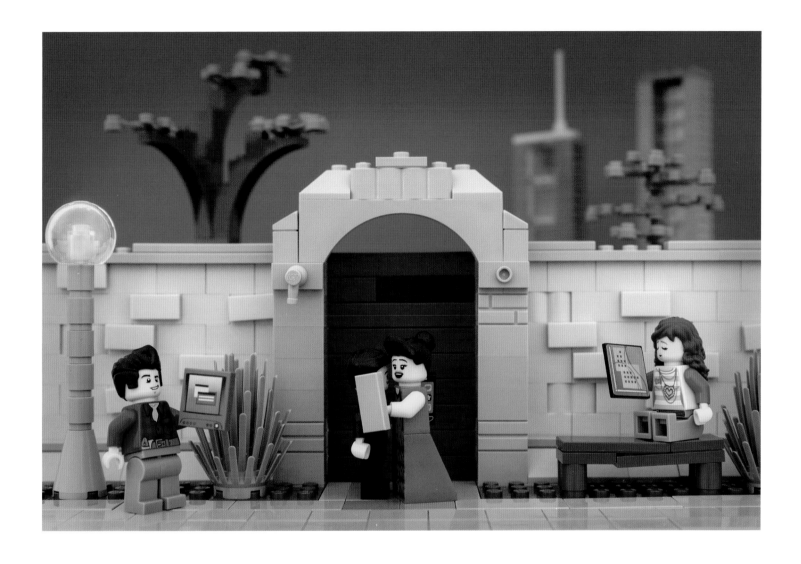

It's hard to find true love, what with all the available screen resolutions and billing options.

Hanging on
to your youth
can reach an
awkward stage.

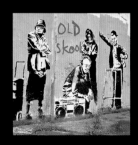

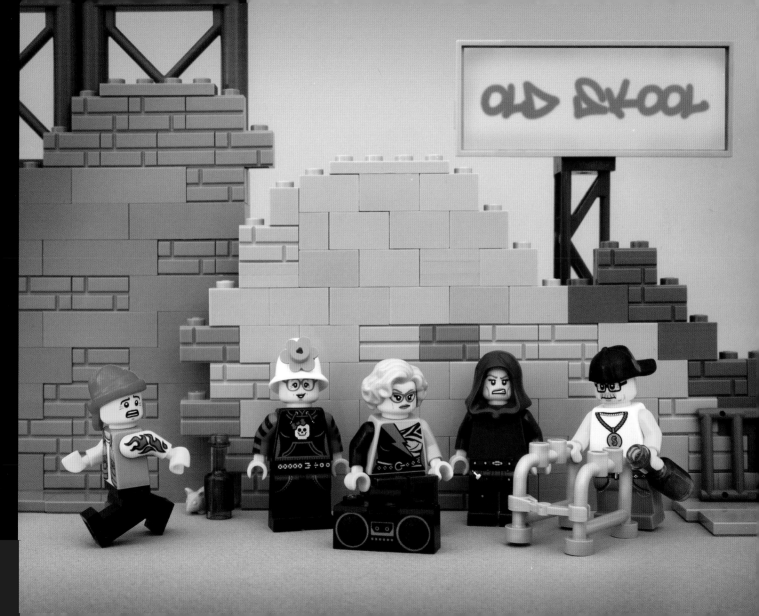

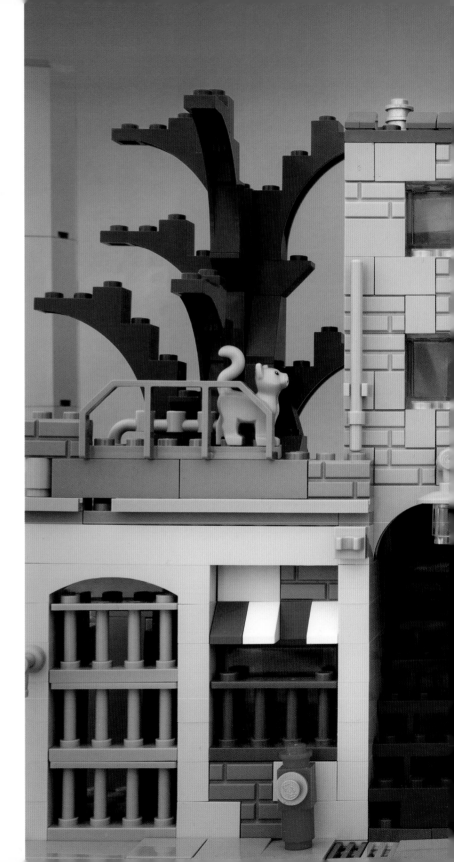

"My great
concern is not
whether you have
failed, but whether
you are content
with your failure."
—Abe Lincoln

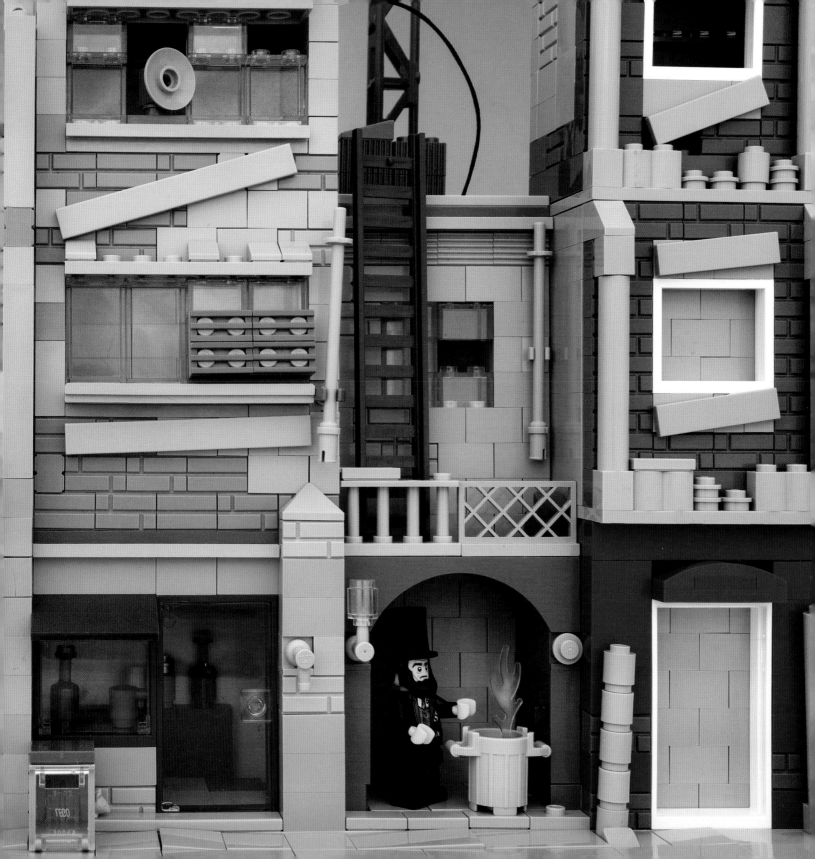

Seize the day!

Live like there's no tomorrow!

It all sounds so stressful.

Maybe it's better to
relax once in a while.

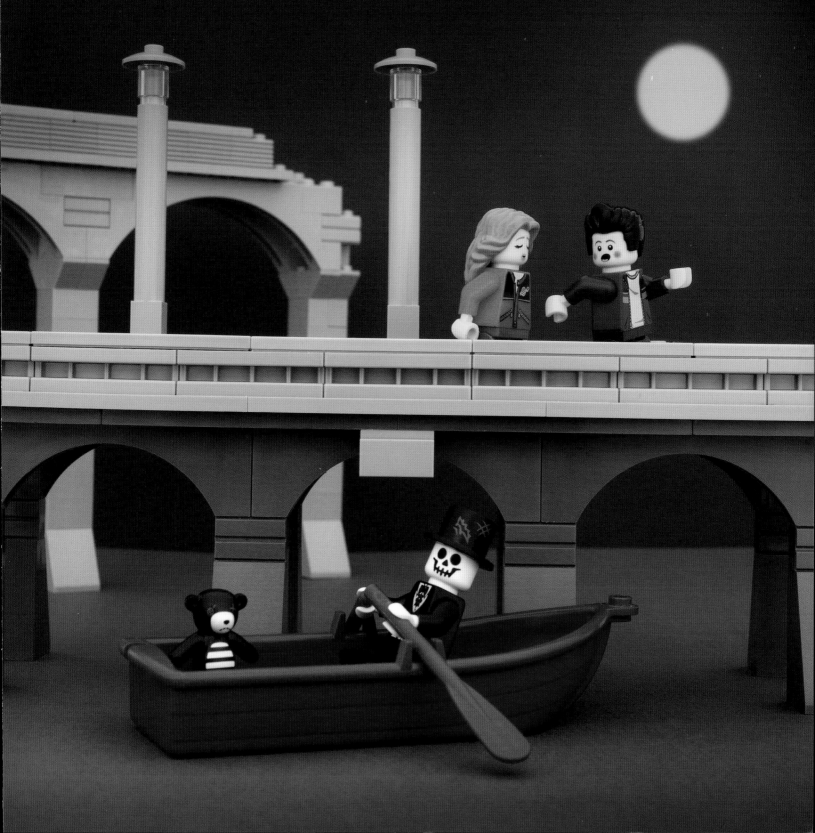

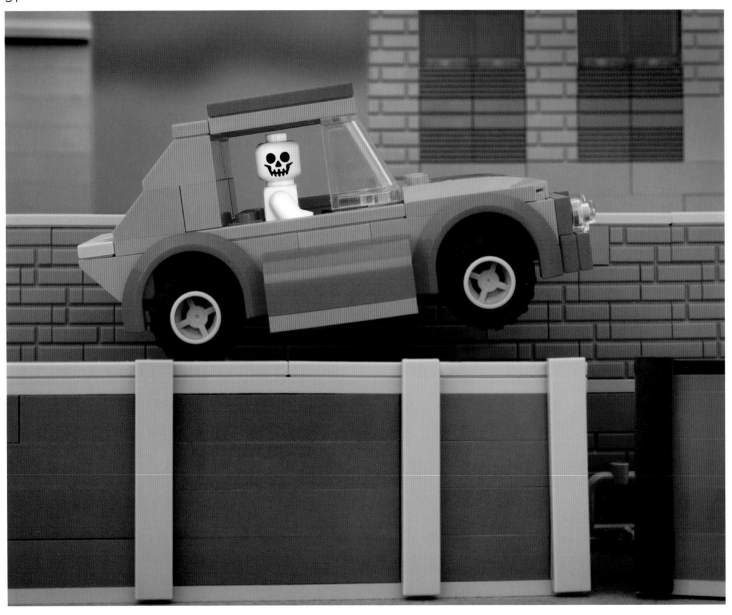

Death usually rides a pale horse, but he owns a used Triumph GT6
for backup when the horse isn't feeling well. Be careful,
it's a death trap.

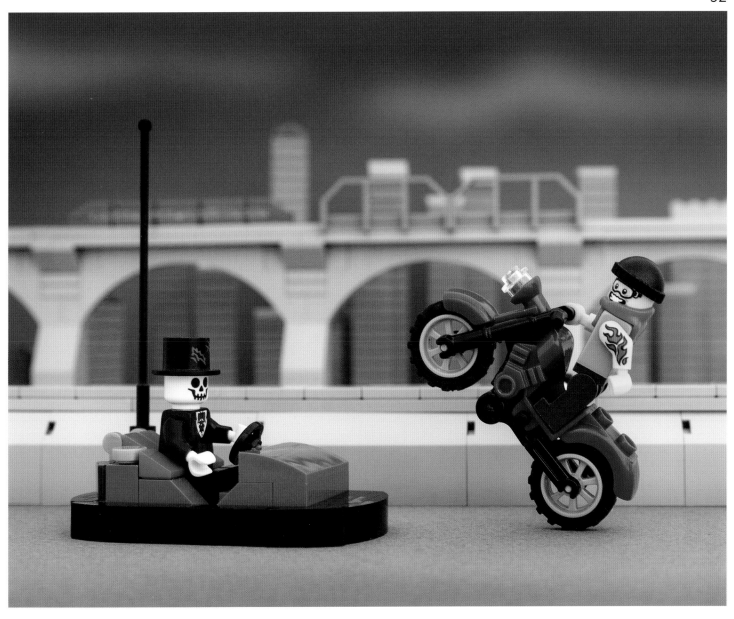

Things that go bump in the night.

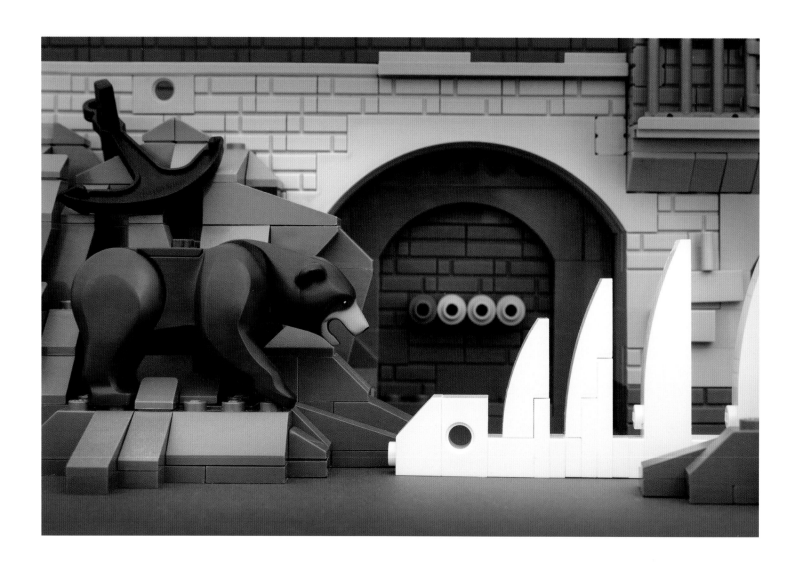

There must be something in the water.

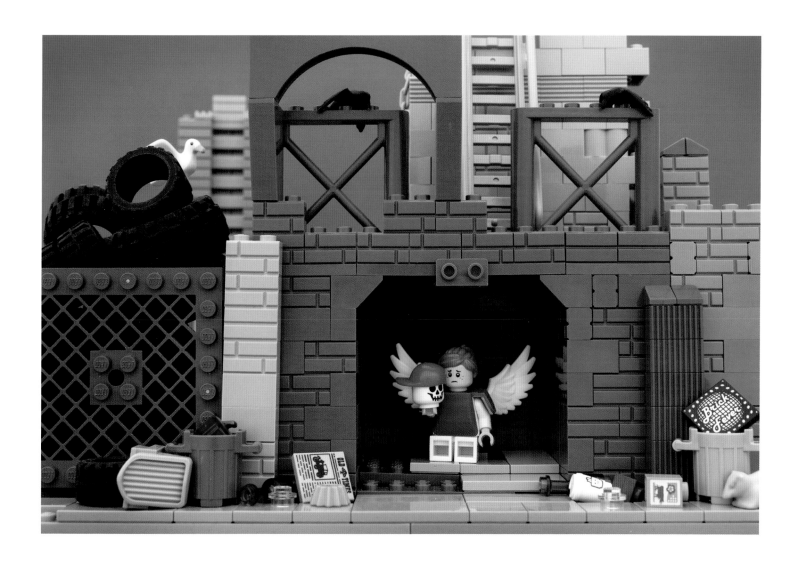

"It is said that your life flashes before your eyes just before you die. That is true, it's called Life." —Terry Pratchett

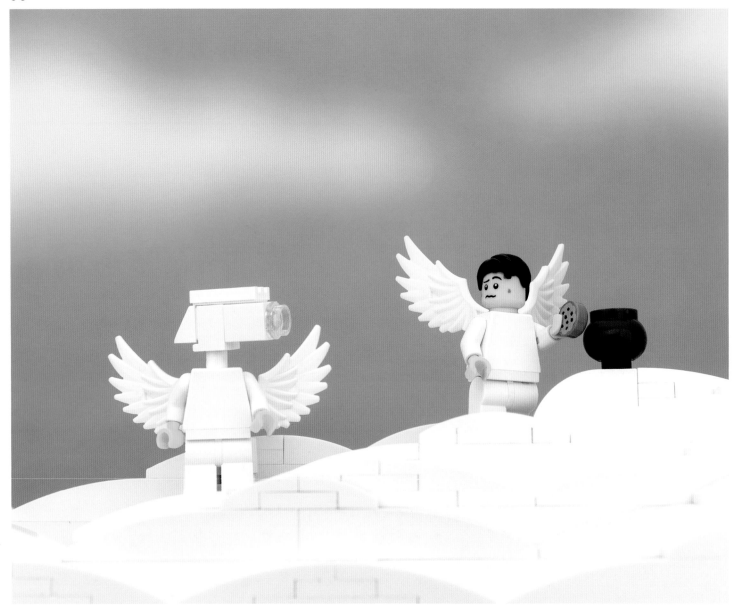

He knows if you've been bad or good.

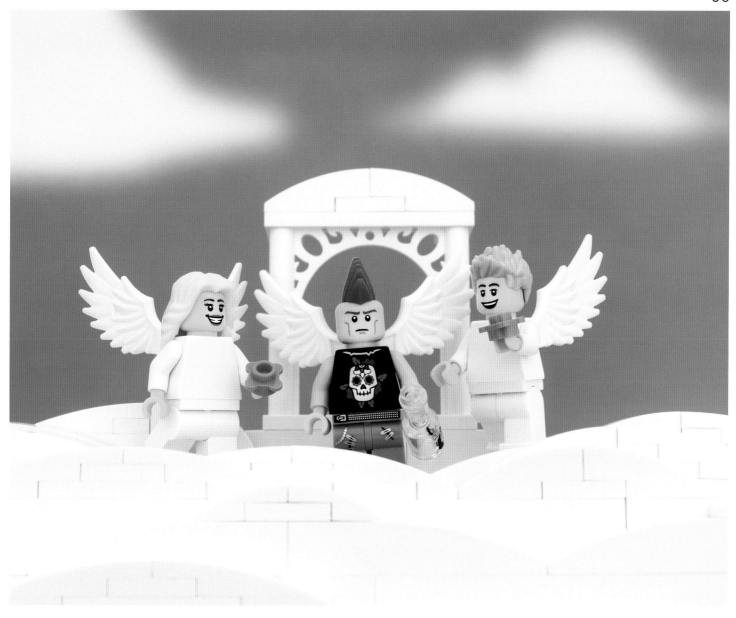

It's going to be a long afterlife.

He rode with
sunglasses
a-twinkle,
spilling paint
beneath a
painted sky.

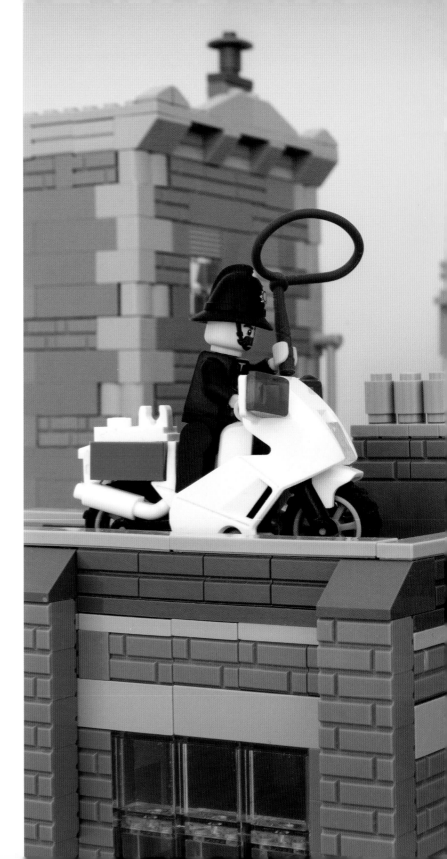

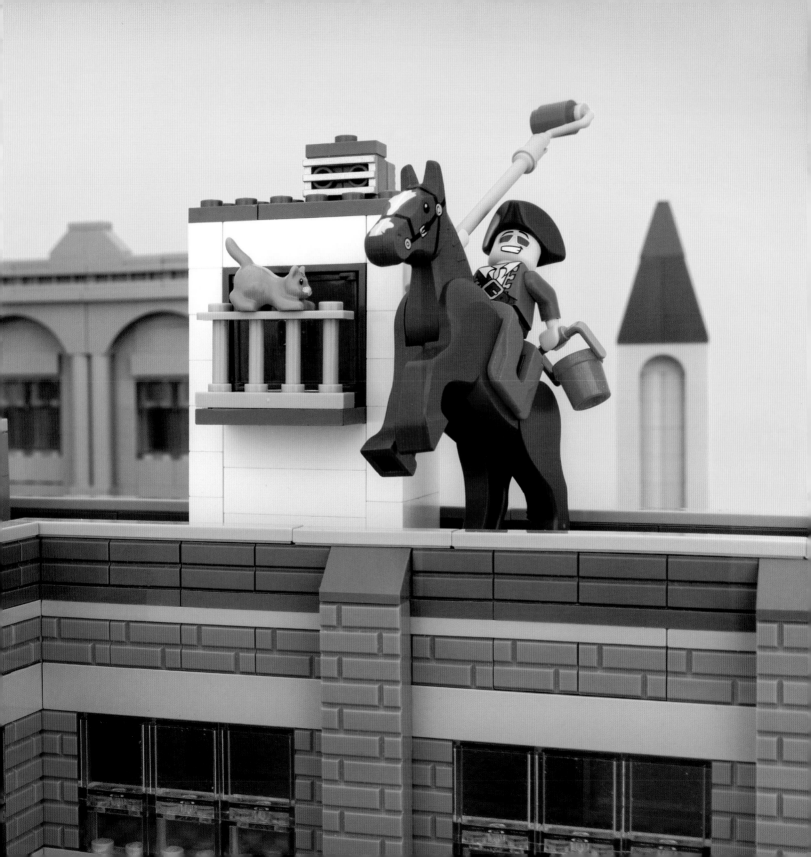

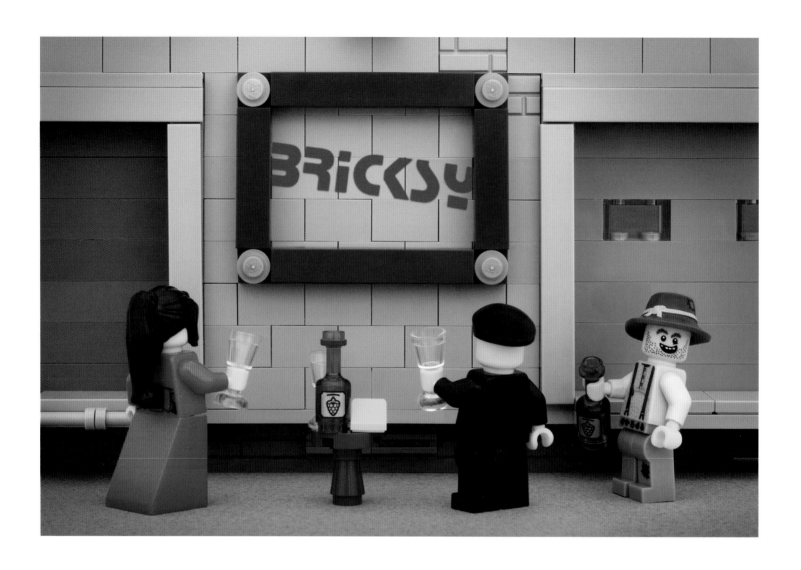

Art is what you can get away with at a gallery opening.

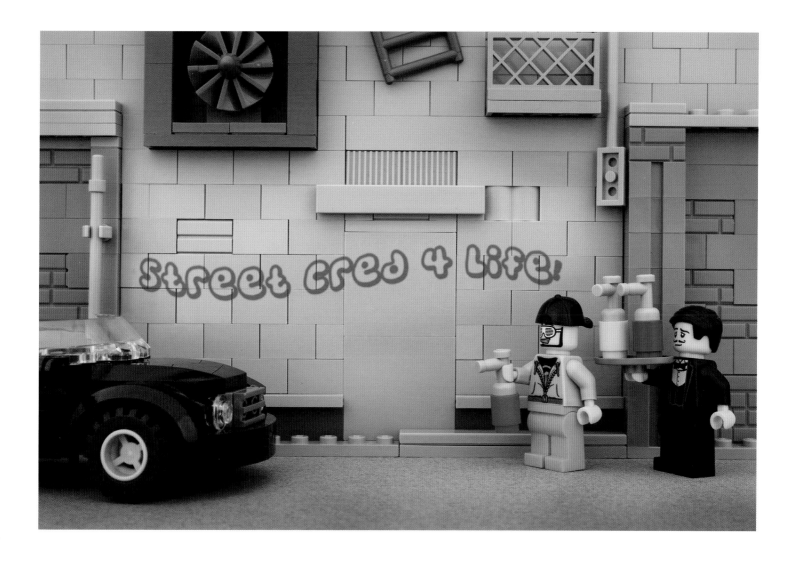

There's always hope, especially if
you tie it to your wrist.

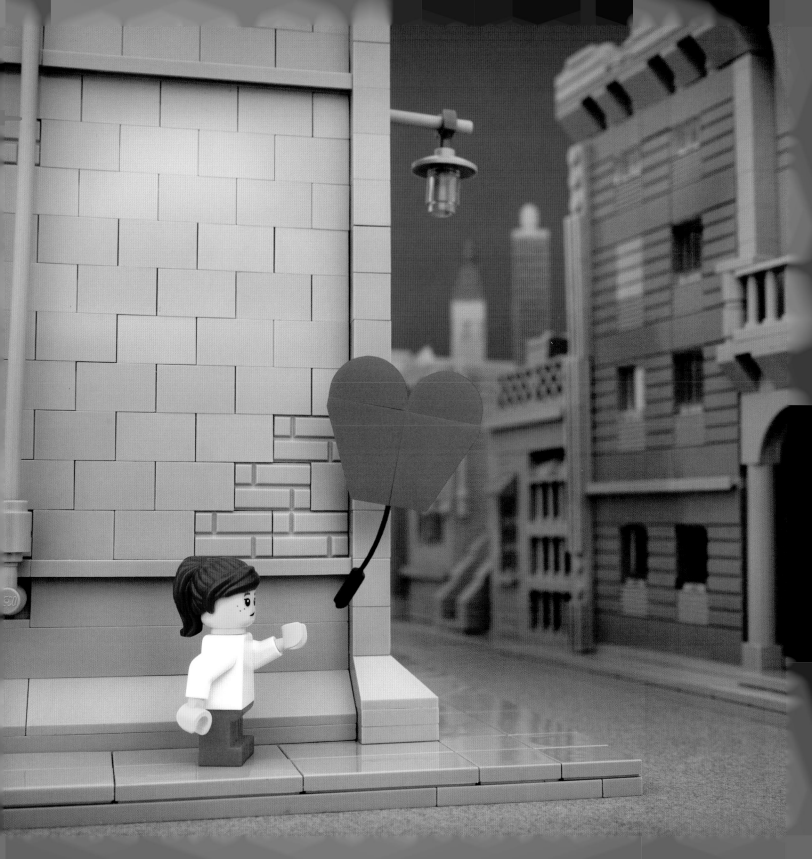

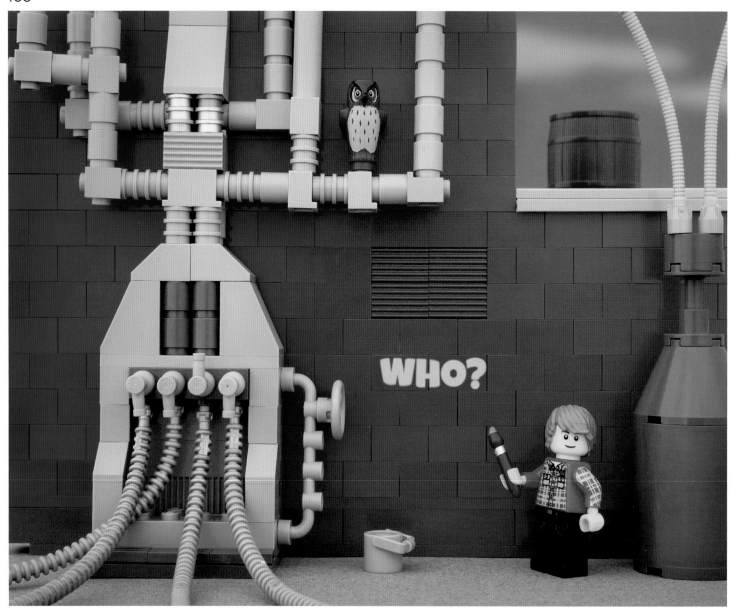

FAQ

How did *Bricksy* begin?

Bricksy was an early spin-off from another project called LEGO London, which features LEGO dioramas of London as you've undoubtedly guessed. London is an art capital, so one of my first ideas for LEGO London was to include a work by Banksy.

I once stayed on Old Street in East London, where street art shimmers like motor oil in a puddle. Banksy had done a lot of work in the neighborhood, including his famous *Pulp Fiction*-inspired stencil painting on the Old Street tube station. Being familiar with the area, I think it was a natural choice to re-create that particular Banksy work in LEGO.

My initial idea was to digitally spray-paint the two-dimensional Banksy painting onto the wall of a LEGO building, using some artistic license for my own interpretation. I posed some LEGO minifigures to model for the digital spray-painting. Before long I realized that the three-dimensional minifigures were more compelling than the two-dimensional painting, so I re-created the whole scene in 3-D with LEGO. Banksy's work jumped off the wall and into "real" LEGO life.

After finishing that first LEGO Banksy re-creation I couldn't stop laughing at the incongruity of it all. There is something inherently funny about gritty street scenes being constructed with glossy LEGO bricks. I

took Banksy's *Wall and Piece* off the shelf and plotted more Banksy-inspired works. *Bricksy* began, while LEGO London remains unfinished, for now.

How did you start building LEGO in the first place (as an adult)?

In my other life I'm a serious award-winning photographer, much given to brooding and brow furrowing. That part of my life is known as "Bert." In summer I look after my elementary school-aged daughter when she's not attending various day camps. She doesn't care for too much serious stuff, so we do fun things instead, such as playing with her toys. That part of my life is known as "Ernie."

The thing is, "Bert" never completely disappears, and he wants toy playing to have a purpose. As a compromise, "Bert" and "Ernie" eventually joined forces. My daughter and I continue to play with toys, but we also set up a little tabletop photo studio where we could make toy dioramas and take pictures of them.

LEGO was the chosen toy of summer 2013. While my daughter made a series of high-concept scenes combining crocodiles, werewolves, and tennis players, I noticed that by combining two LEGO minifigures it was possible to create a feathered-haired, mustachioed classic rocker of the sort that still populate my hometown of Winnipeg, Manitoba.

For a laugh, I decided to make a complete LEGO Manitoba scene, which soon led to a series of all the Canadian provinces. Since there are only ten provinces, the fun ended too soon. I lived in the United States for a couple of years and decided to make LEGO scenes for all fifty states . . . a much harder task given the limitations of June's brick collection.

Eventually the LEGO work was posted to the Internet and was picked up by *Wired* magazine. From there it went viral, and the subsequent addition of LEGO to my professional work has surprised me as much as anyone.

How many LEGO bricks do you have?

Not as many as is commonly assumed. I have, or should I say my daughter has, about as much LEGO as your standard spoiled North American kid. Keeping track of the inventory takes up a lot of valuable brain space. If we get too much LEGO I may well forget how to use a zipper.

How do you photograph the dioramas?

They are photographed using only natural light, which is diffused and bounced with reflectors as needed. I try to minimize shiny highlights,

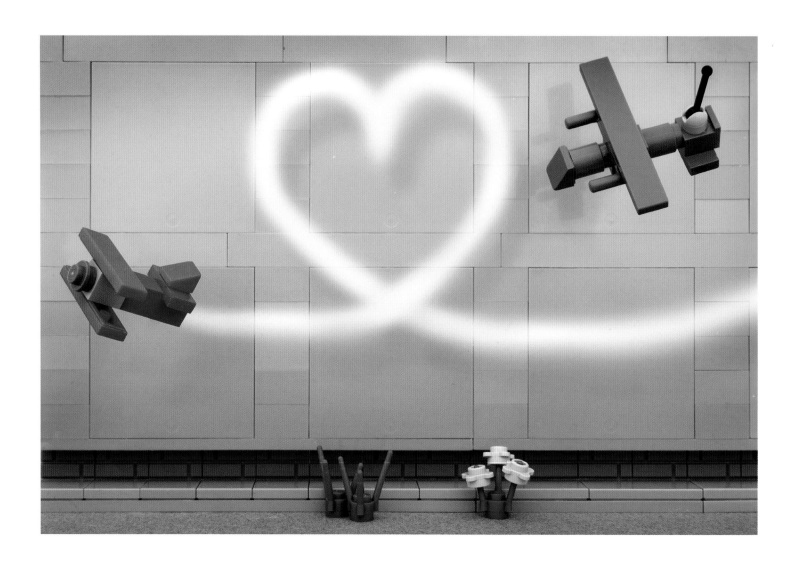

It's never polite to drone on and on.

which can be difficult given LEGO's glossiness. Anything non-LEGO that you see, such as the sky, is made with construction paper.

How long does it take to set up each diorama?

That is a common question with a complicated answer. Each diorama goes through four or five phases.

Phase 1 is conceptualizing what the scene should look like. I do this while walking around town, often passing right by friends who I don't notice while in this daydreaming state. It's a social hazard.

Phase 2 is building the diorama. The LEGO diorama is always different than the conceptualized version due to limited bricks, limited colors, and limits in the laws of physics. Building a small scene takes an hour or two, while large scenes are tinkered with over a couple of days.

Phase 3 is photographing the diorama. The photography is a process of trial and error for lighting and compositional adjustments. There's a cycle of taking photographs, reviewing the photographs, going back to tweak the scene, and retaking the photos until everything comes together.

Phase 4 is postproduction of the digital image file. There is very little digital work done on these photos except for one Herculean task, which is cookie crumb removal. Crumbs, lint, and dust that are invisible

to the human eye become very noticeable when the pictures of LEGO are blown up larger than life-size, which is often. I'm starting to do this with an analog technique, which involves rinsing the bricks with water before taking the picture.

The other digital work that occurs occasionally is adding floating objects to a scene, such as Mousy Poppins on pages 9-10.

Phase 4 should be the work's end, but it can be followed by a fifth phase. Phase 5 is when I review a finished picture a week or two after its completion and decide to make the whole thing over again. Everything is rebuilt from scratch. None of these dioramas stays together long.

Is it weird to be playing with LEGO while your daughter is at school?

I try to avoid talking about this with people leading productive lives.

But you're having lots of fun playing with LEGO all day, right?

LEGO is associated with fun because it's a toy, but as an artistic medium it's not much different than carving soapstone or making a paper collage. It's challenging just like any other creative endeavor. That said, it is fun in the way that solving a puzzle is fun. It has been said that kids don't play because it's easy; they play because it's hard. That's how I feel about making things with LEGO.

Legend

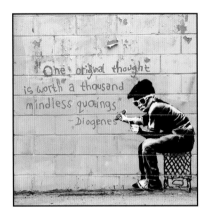

Page vi

Ray Mock, www.carnagenyc.com

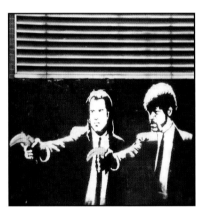

Page viii

Gordon Gibbens, www.flickr.com/
photos/82786929@N00

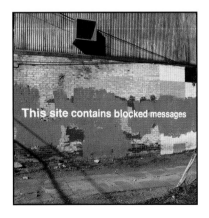

Pages 1-2

Ray Mock, www.carnagenyc.com

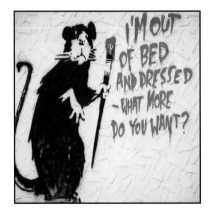

Pages 3-4

Lord Jim, www.flickr.com/photos/lord-jim

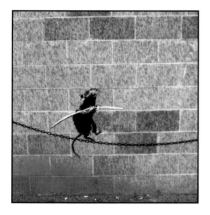

Page 5

Peter Senteris, www.flickr.com/
photos/29045570@N08

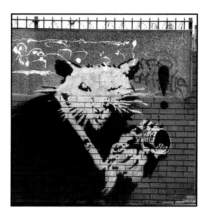

Page 6

Kevin Flemen, www.flickr.com/photos/
kfxposure

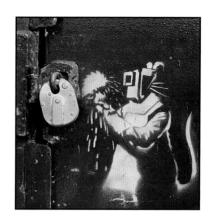

Page 7

Sam Martin, www.flickr.com/
photos/31693368@N00

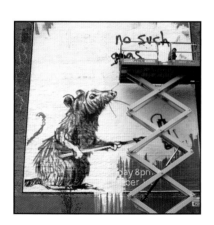

Page 8

Ray Mock, www.carnagenyc.com

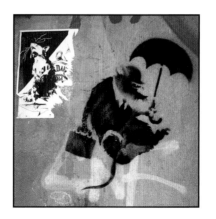

Pages 9-10

Luna Park, www.flickr.com/
photos/54481803@N00

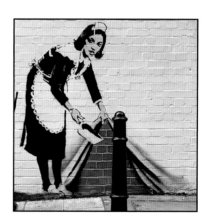

Pages 11-12

Sam Martin, www.flickr.com/
photos/31693368@N00

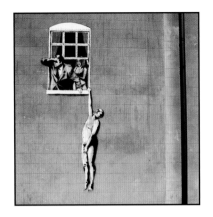

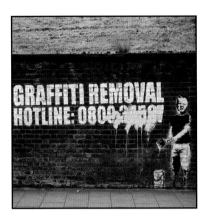

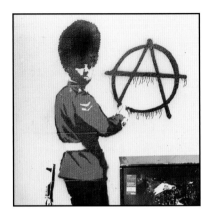

Pages 13–14

Luna Park, www.flickr.com/
photos/54481803@N00

Page 15

Kevin Flemen, www.flickr.com/photos/
kfxposure

Page 16

Kevin Flemen, www.flickr.com/photos/
kfxposure

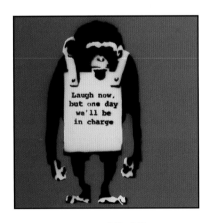

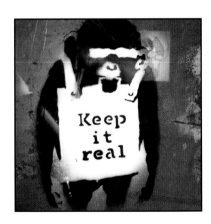

Pages 17–18

Gordon Gibbens, www.flickr.com/
photos/82786929@N00

Page 19

Sam Martin, www.flickr.com/
photos/31693368@N00

Page 20

Lord Jim, www.flickr.com/photos/lord-jim

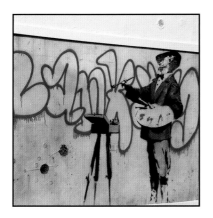

Page 21

Gordon Gibbens, www.flickr.com/
photos/82786929@N00

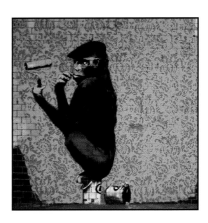

Page 22

Sam Martin, www.flickr.com/
photos/31693368@N00

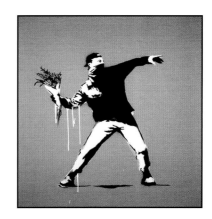

Pages 23-24

Sam Martin, www.flickr.com/
photos/31693368@N00

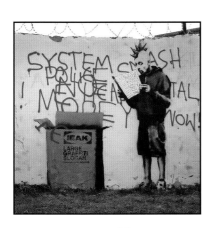

Page 25

eddiedangerous, www.flickr.com/
photos/13899429@N08

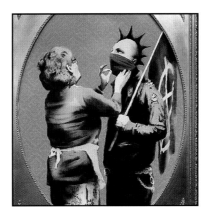

Page 26

Sam Martin, www.flickr.com/
photos/31693368@N00

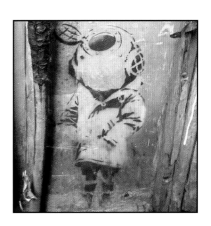

Pages 27-28

Phoenix the Street Artist, www.flickr.
com/photos/49410366@N06

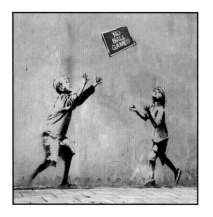

Page 29

Neil Edwards, www.flickr.com/
photos/24287492@N02

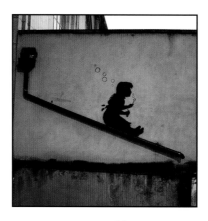

Page 30

Sam Martin, www.flickr.com/
photos/31693368@N00

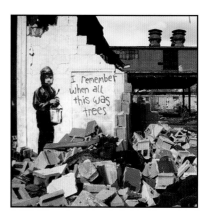

Pages 31–32

eddiedangerous, www.flickr.com/
photos/13899429@N08

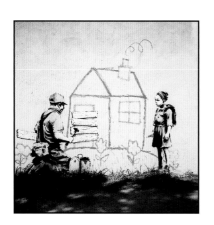

Pages 33–34

Michelle Fierro, www.instagram.com/
whatvinyldummy

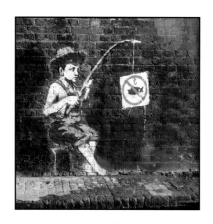

Pages 35–36

Sam Martin, www.flickr.com/
photos/31693368@N00

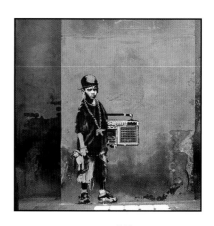

Page 37

Sam Martin, www.flickr.com/
photos/31693368@N00

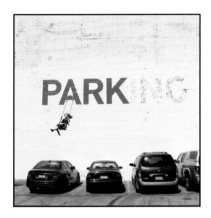

Page 38

Lord Jim, www.flickr.com/photos/lord-jim

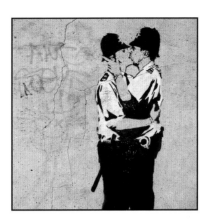

Pages 39-40

Glenn Arango, www.flickr.com/
photos/93711503@N00

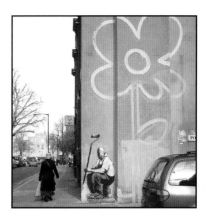

Pages 41-42

Neil Edwards, www.flickr.com/
photos/24287492@N02

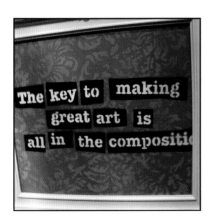

Pages 43-44

eddiedangerous, www.flickr.com/
photos/13899429@N08

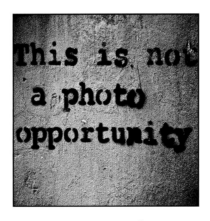

Pages 45-48

Glenn Arango, www.flickr.com/
photos/93711503@N00

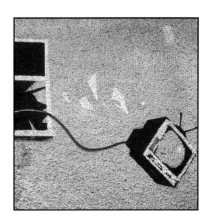

Pages 49-50

Sam Martin, www.flickr.com/
photos/31693368@N00

117

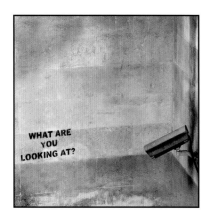

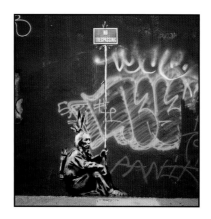

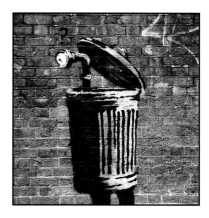

Pages 51–52
Neil Edwards, www.flickr.com/
photos/24287492@N02

Page 53
Glenn Arango, www.flickr.com/
photos/93711503@N00

Page 54
Kevin Flemen, www.flickr.com/photos/
kfxposure

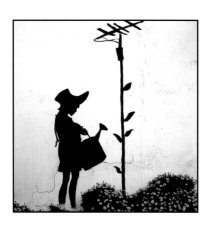

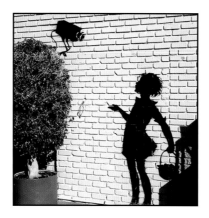

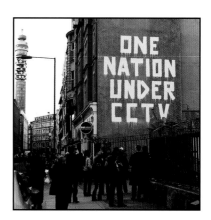

Page 55
Lord Jim, www.flickr.com/photos/lord-jim

Page 56
Lord Jim, www.flickr.com/photos/lord-jim

Pages 57–58
Sam Martin, www.flickr.com/
photos/31693368@N00

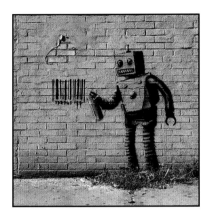

Page 59

Ray Mock, www.carnagenyc.com

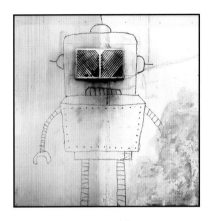

Page 60

Sally Ilett, www.flickr.com/
photos/50449065@N03

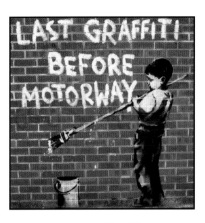

Pages 61-62

Gordon Gibbens, www.flickr.com/
photos/82786929@N00

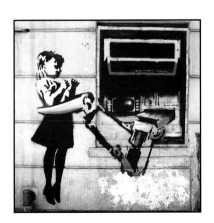

Pages 63-64

Kevin Flemen, www.flickr.com/photos/
kfxposure

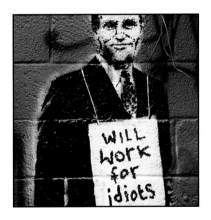

Pages 65-66

Ray Mock, www.carnagenyc.com

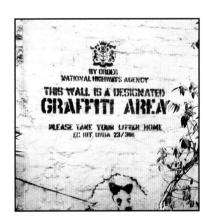

Page 67

Ray Mock, www.carnagenyc.com

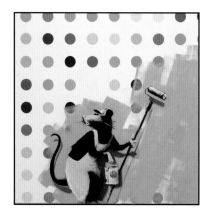

Page 68

Sam Martin, www.flickr.com/
photos/31693368@N00

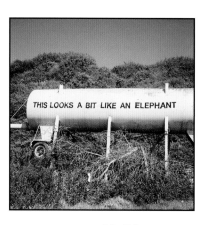

Pages 69-70

Michelle Fierro, www.instagram.com/
whatvinyldummy

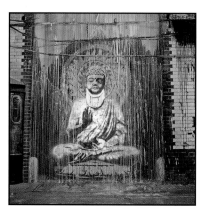

Page 71

Neil Edwards, www.flickr.com/
photos/24287492@N02

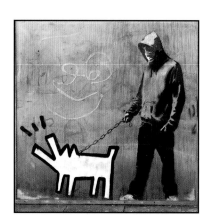

Page 72

Sam Martin, www.flickr.com/
photos/31693368@N00

Pages 73-74

Sam Martin, www.flickr.com/
photos/31693368@N00

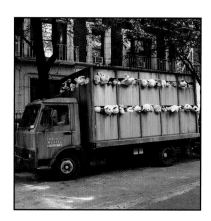

Page 75

Ray Mock, www.carnagenyc.com

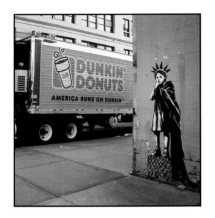

Page 76

Luna Park, www.flickr.com/
photos/54481803@N00

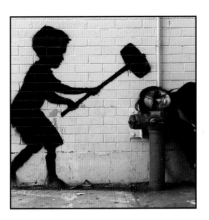

Page 77

Ray Mock, www.carnagenyc.com

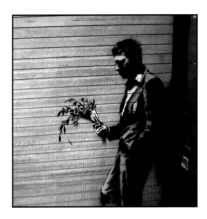

Page 78

Ray Mock, www.carnagenyc.com

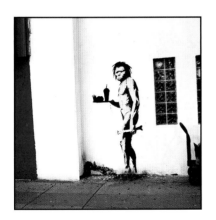

Page 79

Lord Jim, www.flickr.com/photos/lord-jim

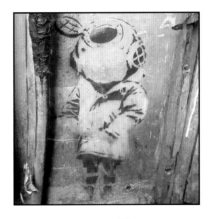

Page 80

Phoenix the Street Artist, www.flickr.
com/photos/49410366@N06

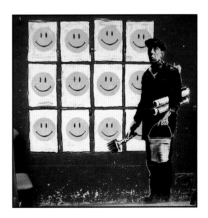

Pages 81–82

Luna Park, www.flickr.com/
photos/54481803@N00

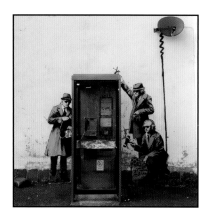

Page 83
Sally Ilett, www.flickr.com/
photos/50449065@N03

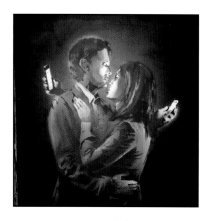

Page 84
Sally Ilett, www.flickr.com/
photos/50449065@N03

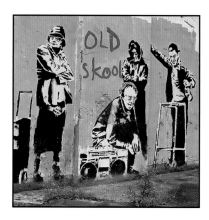

Pages 85–86
Sam Martin, www.flickr.com/
photos/31693368@N00

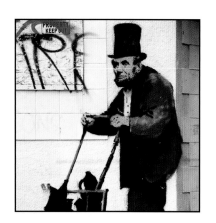

Pages 87–88
Ray Mock, www.carnagenyc.com

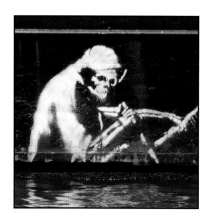

Pages 89–90
Sally Ilett, www.flickr.com/
photos/50449065@N03

Page 91
Kevin Flemen, www.flickr.com/photos/
kfxposure

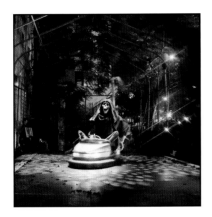

Page 92

Luna Park, www.flickr.com/
photos/54481803@N00

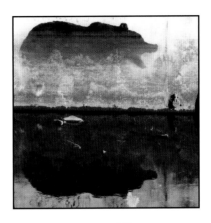

Page 93

Gordon Gibbens, www.flickr.com/
photos/82786929@N00

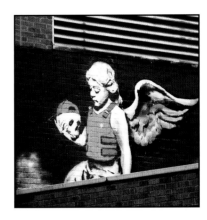

Page 94

Sam Martin, www.flickr.com/
photos/31693368@N00

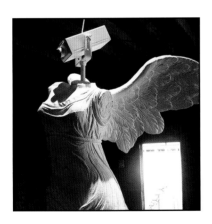

Page 95

Lord Jim, www.flickr.com/photos/lord-jim

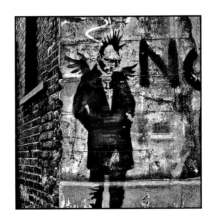

Page 96

Kevin Flemen, www.flickr.com/photos/
kfxposure

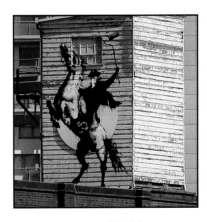

Pages 97-98

Neil Edwards, www.flickr.com/
photos/24287492@N02

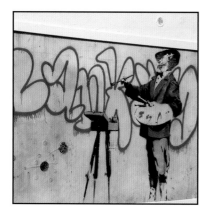

Page 99

Gordon Gibbens, www.flickr.com/
photos/82786929@N00

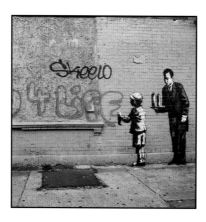

Page 100

Ray Mock, www.carnagenyc.com

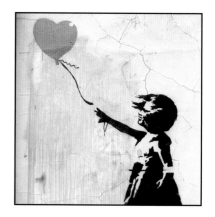

Pages 101-102

Kevin Flemen, www.flickr.com/photos/
kfxposure

Page 103

eddiedangerous, www.flickr.com/
photos/13899429@N08

Page 107

Neil Edwards, www.flickr.com/
photos/24287492@N02

Page 125

Sally Ilett, www.flickr.com/
photos/50449065@N03

Acknowledgments

A big thanks to Kevin Flemen, Lord Jim, Sam Martin, Gordon Gibbens, Neil Edwards, Sally Ilett, Phoenix the Street Artist, Glenn Arango, Luna Park, eddiedangerous, Michelle Fierro, Peter Senteris, and Ray Mock. While this group may sound like the lineup for a 1970s progressive rock band, they are actually the lovely people who provided photos of the real Banksy works in the thumbnails and the legend section. One thing I've learned from my sideways entrance into the street art world is that it's populated with a fantastic bunch of people.

I am grateful to Alice Yoo, who was the first person to introduce *Bricksy* to the wider world on her excellent website, *My Modern Met*.

Thanks to Jenny Pierson, who is always wonderful to work with, and the rest of the staff at Skyhorse Publishing.

My wife, Tetjana, and daughter, June, are the foundation of everything good in my life, including the work on these pages.

Bricksy is inspired by Banksy's art and clever mischief making.

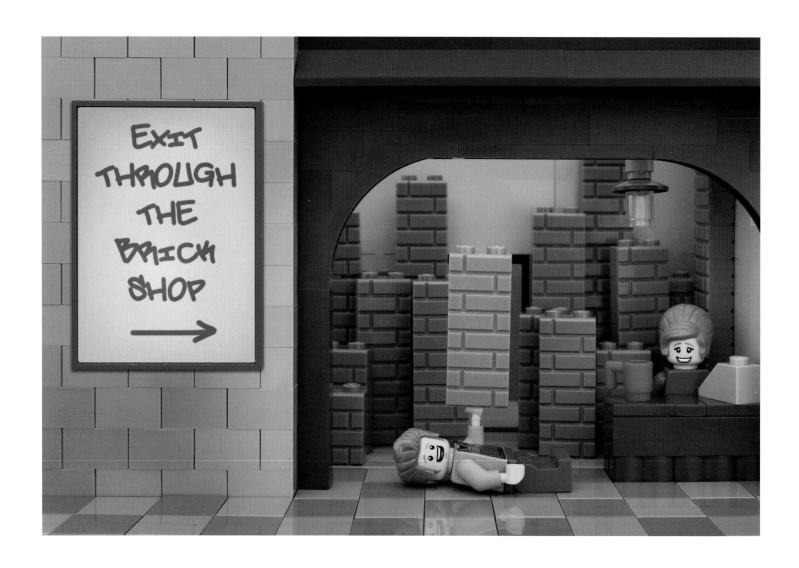